Professional Digital Techniques for

Photographing Bar and Bat Mitzvahs

Stan Turkel

AMHERST MEDIA, INC. ◻ BUFFALO, NY

Copyright © 2010 by Solomon Turkel.

All photographs by the author unless otherwise noted.

All rights reserved.

Published by:
Amherst Media, Inc.
P.O. Box 586
Buffalo, N.Y. 14226
Fax: 716-874-4508
www.AmherstMedia.com

Publisher: Craig Alesse
Senior Editor/Production Manager: Michelle Perkins
Assistant Editor: Barbara A. Lynch-Johnt
Editorial Assistance provided by: Sally Jarzab, John S. Loder, and Carey Maines.

ISBN-13: 978-1-58428-270-9
Library of Congress Control Number: 2009903896

Printed in Korea.
10 9 8 7 6 5 4 3 2 1

CONTENTS

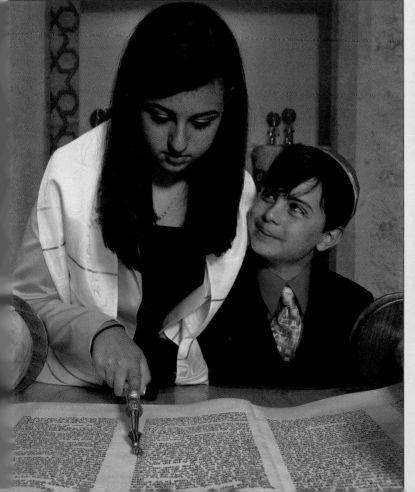
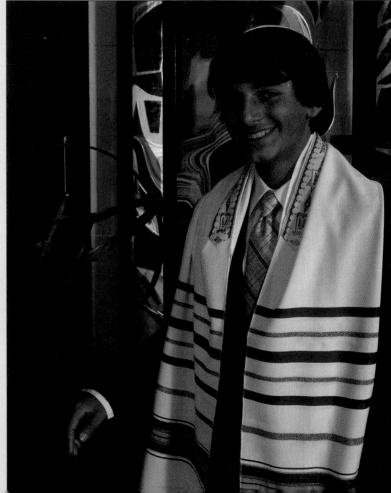

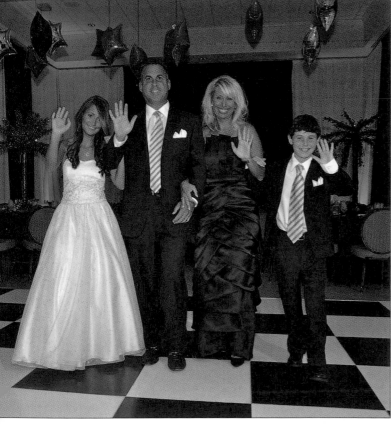

ABOUT THE AUTHOR

If I look back at my life, with all of its twists and turns, I realize that I was destined to be a photographer of Jewish weddings and mitzvahs. Being a first-generation American, the child of Holocaust survivors, made a mark on me. You see, I grew up

Photograph by Dana Turkel.

without grandparents, and hardly any relatives at all, since all were lost in the war. What we did have was a handful of pictures that my parents were able to save and bring with them to the United States. I understood at a very young age the importance of having family photographs.

Like many children of Holocaust survivors, I ended up going to a Jewish Orthodox *yeshiva* (religious day school), not because we were Orthodox, but because the tuition was free through a Jewish agency. Here I learned all about Jewish Orthodox life, even though I was not brought up that way.

At the age of thirteen, I had my bar mitzvah. Though my parents were not well off, they hired a photographer, and I had an album of pictures from my bar mitzvah. How great, I thought, since I was the only one of my four siblings who had this. Here I saw the importance of these milestone event photos. I bought my first camera with money from my bar mitzvah and stared a lifelong hobby turned profession.

Fast forward a few years and several careers, all of which helped prepare me for my current love, photographing Jewish weddings and bar/bat mitzvahs. As an early adopter of digital photography (over six years now), I have been able to experiment with many systems and create a look and style with my images that is truly unique to Jewish event photography.

While the equipment is great and the technology allows me to overcome many technical difficulties, such as low light and fast focus, I can't ignore the fact that so many things had to happen in my life to give me the insight and creativity to capture these special events that would be cherished by generations to follow.

There are two Jewish beliefs which I hold to be true. The first is that one's entire life—the person you will marry, the number of children you will have, the life you will be able to lead—is determined at the time of one's birth. The second is that while standing under the chuppah during the wedding ceremony, you are as close to the Divine as you will ever be. A similar feeling of grace comes to me while working with a child of mitzvah age and his/her family. Seeing the look of pride and admiration in the parents' eyes is such a beautiful sight.

For me to have been given the ability to photograph and share in these most beautiful occasions has truly been a gift. I graciously acknowledge this gift I've been given, and I give thanks.

SO MANY THINGS HAD TO HAPPEN IN MY LIFE TO GIVE ME THE INSIGHT AND CREATIVITY TO CAPTURE THESE SPECIAL EVENTS.

ACKNOWLEDGMENTS

In my first book about Jewish weddings, I thought about and acknowledged all those people who had a lot to do with my profession and the book in general. Here I am on my second book, and as I think about what has influenced me the most about mitzvahs, the first thought that comes to my mind are our four wonderful children, Sharon, Iris, Harel, and Dana.

You see, my wife, Yael, and I went through three bat mitzvahs and one bar mitzvah. We know firsthand what it means to prepare for and take part in this wonderful, hectic, emotional occasion. With each child's mitzvah, we learned something new. Most importantly, we learned about each child as they prepared for their mitzvahs. Think about the courage it takes at the young age of twelve or thirteen to stand in front of several hundred people in a synagogue and read from the Torah in a

foreign language (Hebrew) and then give a speech. Each one of our children gave us such *nachus* (pleasure) as they became bar and bat mitzvahs.

My dear children, I thank each and every one of you for willingly giving so much of your time and energies at such young ages to prepare for your mitzvahs. As I wrote this book, my mind drifted many times to the delightful memories I have of seeing you on the *bimah* (platform from where the Torah is read), reciting your Torah portions with such confidence and poise. I am sure these memories are a big part of what makes this book so important to me. These memories, I am sure, also help me to do my best work for all of those families whose mitzvahs I photograph. Thank you, children.

A book on photographing bar and bat mitzvahs? Go figure. The folks at Amherst Media have made writing this book such a pleasure. Seeing the need is one thing, turning it into a reality is another. Thank you for making this book possible. I know there are many, many photographers who will be thanking you in the years to come.

DEDICATION

Working as a full-time photographer for weddings and mitzvahs takes a tremendous amount of time during the course of the year. I have been doing this for so long now, and when I consider the time spent over many years, it is hard to imagine the number of days and nights my dear wife Yael spent alone while I was working, photographing these events, processing the images, and writing my books.

I AM SO GRATEFUL TO HAVE BEEN BLESSED WITH A WIFE WHO NOT ONLY UNDERSTANDS ME BUT SUPPORTS ME IN ALL I DO.

I am so grateful to have been blessed with a wife who not only understands me but supports me in all that I do. We have just passed our thirty-five years of marriage milestone, and when I look at all I have accomplished in those years, I know that she has been and will continue to be my foundation.

Dear Yaeli, thank you for always giving me the room to grow, the confidence to believe, and the love to nurture the things I most love to do. Your patience and understanding are way beyond reasonable, and for this, I dedicate this book to you.

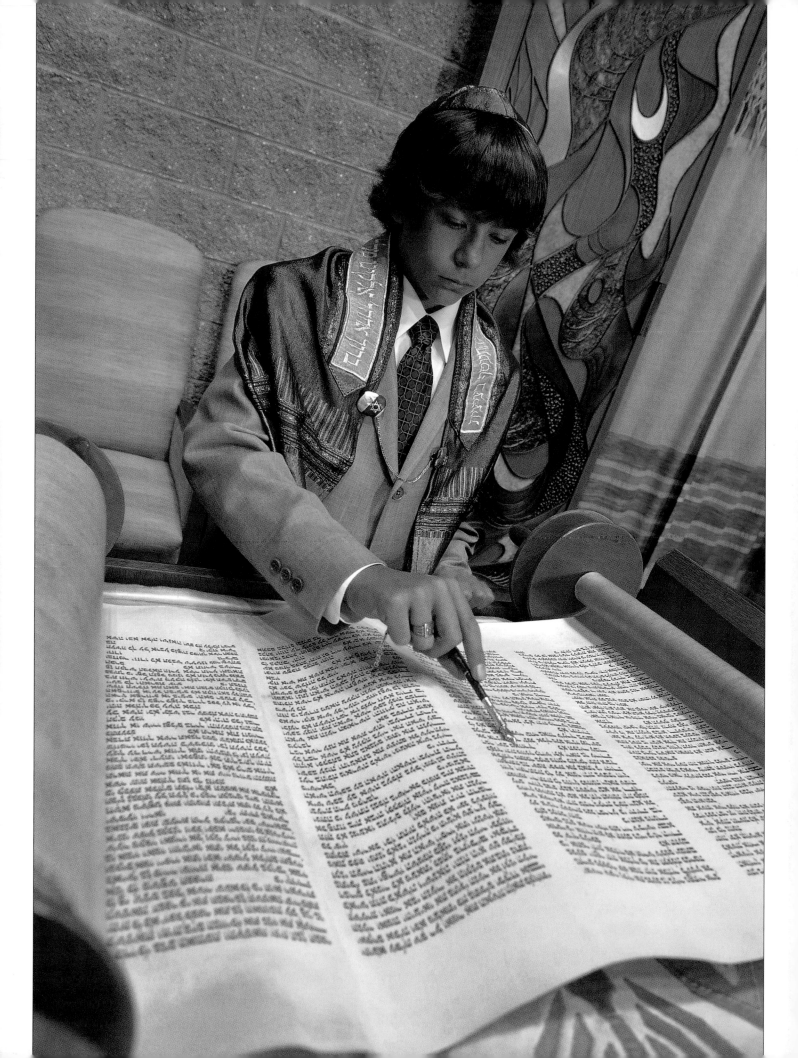

INTRODUCTION

According to Jewish law, a male child becomes a "responsible male"—a *bar mitzvah*—at the age of thirteen. This happens automatically, and no special ceremony is required to attain this designation. At this age, the male is required to observe

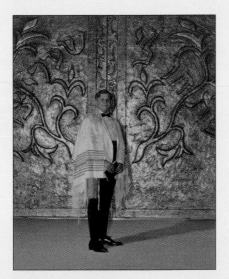

Facing page—Bar mitzvah reading from the Torah. **Above**—Author's bar mitzvah images, taken May 1966 in Baltimore, MD.

the religious mitzvahs (set of six hundred and thirteen commandments traditionally acknowledged to have been given by G-d or decreed by the rabbis).

CEREMONY AND CELEBRATION

Though no ceremony is required for the child to make this transition, over time, Jewish families developed special customs to mark the thirteenth birthday—such as being called to read from the Torah in front of the congregation or leading part of the prayer service. Families would have a small, festive meal to mark the occasion. At the beginning of the 1900s, Jewish girls (primarily in the Conservative and Reform denominations) were honored with their own ceremony celebrating their coming of age—the *bat mitzvah*.

The biggest change to the bar or bat mitzvah scene came about after World War II. For many Jews arriving in the United States after the war,

the bar/bat mitzvah celebration became a means to show that they had survived and prospered in their new home. Small parties grew in size, and lavish celebrations became the norm. This was the case at my own bar mitzvah in May 1966. As a first-generation American from Holocaust survivors, I had a bar mitzvah at a prominent synagogue, Beth Jacob of Baltimore, MD, with a lavish dinner party the Saturday evening following the morning service where I read from the Torah. The guests were dressed in tuxedos and evening gowns, and I wore a white tuxedo. Our family looked like something out of a Las Vegas lounge act. Mind you, my parents came to this country with nothing but their clothes. Both my parents worked middle-class jobs, but they needed to show that they had made it as new Jewish Americans.

I was the only one of my four siblings to have a mitzvah, and in some respects, this changed my life. How, you ask? With the money I got in gifts, I purchased a Yashica 35mm reflex camera and started a lifelong passion for photography.

A GROWING TREND

If you grew up in or near any large U.S. metropolitan area within the last thirty years, I'd bet you have been to at least one bar/bat mitzvah. Maybe a family member or friend invited you as an adult, or perhaps one of your Jewish classmates invited you when you were a kid. Of all of the Jewish events, the bar/bat mitzvah is perhaps the most recognized and frequented by non-Jews.

The bar mitzvah has been the subject of movies, books, plays—you name it. What was once a small religious ceremony for males of the Jewish faith has become a major industry in this country. Today, bar and bat mitzvah ceremonies are a

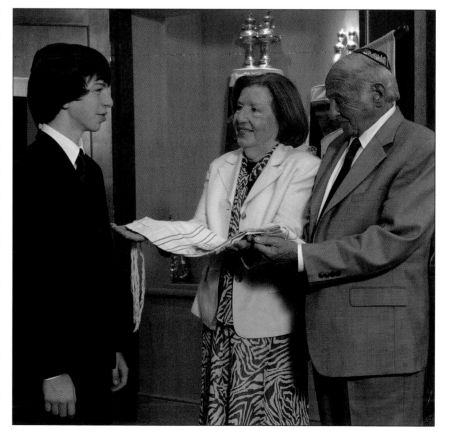

Proud grandparents presenting the bar mitzvah boy a tallit (prayer shawl). These are sometimes handed down over several generations.

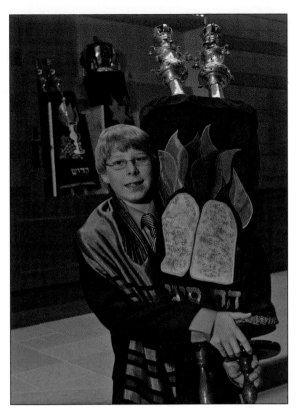

Getting an image of the bar mitzvah boy holding a Torah scroll is a must. The photo will be a favorite among parents and relatives.

major source of income for party planners, caterers, DJs, bands, party decorators, event venues, and of course, photographers (both photo and video).

With typical expenditures in the $10,000 to $20,000 range, mitzvahs are second only to weddings when it comes to money spent for a catered affair. Large, themed parties are common, in all types of settings. The vendors and venues are booked two to three years in advance, with much competition among the mitzvah families to reserve their date before anyone else books it, and it seems that every big, elaborate celebration raises the bar higher and higher.

ABOUT THIS BOOK

Effectively and efficiently photographing a bar or bat mitzvah requires prior knowledge of what will take place during the event. This book, therefore, provides information about the bar/bat mitzvah. You will learn what to expect, when to expect it, and what photographs you can and should take. You'll learn about the various components and sacred objects used in the ceremony and will gain insight on meeting unique challenges (e.g., photographing a child holding a thirty-pound Torah is a challenge at times, and knowing the right techniques can make all the difference in the final outcome of this very important photograph). You'll also learn some important strategies for lighting and posing; my techniques for bouncing light and using indirect light can help you capture some dramatic lighting effects that will allow you to produce prize-winning images that are sure to win clients over. Also covered are essential tips on where to advertise, what packages sell best, and who the gatekeepers are for getting business; after all, technique means little to your financial well-being if you have no audience to purchase your work.

Finally, this book includes a frequently asked questions chapter, for those who need the information in a hurry or just want to get a feel for the questions others have had about bar and bat mitzvahs. You will also find a glossary of Jewish words and terms—some Hebrew and some Yiddish—that are very helpful to know when photographing mitzvahs.

Let's get started!

1. THE MITZVAH CELEBRATION

What was once a small religious life-cycle event among Jewish boys at the age of thirteen has changed dramatically over the last fifty years. This is especially true of the American bar and bat mitzvah, which has become a rite of passage—a transition from childhood to adulthood—among Jewish children, both boys and girls.

Once the synagogue has decided what Torah portion the child will be reading on the particular week of the child's birthday according to the Jewish calendar, tutoring begins with the child preparing to read the portion in Hebrew. The parents start the process of planning this special *simcha* (celebration)—usually years in advance—by identifying and booking all of the services they will need or want. This list can become quite extensive depending on the tastes and budget of the mitzvah family. The following is a list of items typically considered for a mitzvah.

banquet hall
caterer and bar
DJ/band
photography
videography
decorations
invitations/postage
entertainment

florist
favors and gifts
Judaica (religious items
 used during the ceremony)
clothing
cake
Sunday brunch

Planning for a bar or bat mitzvah celebration can be a daunting task. Today's mitzvah family will typically book not only a photographer but also a videographer, a venue, a DJ, and a florist. The family often decorates the venue with a theme in mind. As you can see, there's a reason why planning for the event can start a couple of years before the mitzvah service is to take place.

From this list, it is easy to see that a photographer's price is just one of many line items that need to be budgeted for. The first five items on the list are usually booked early to get the preferred vendor and the best price. It is often assumed that a family booking a mitzvah photographer in 2008 for a 2009 mitzvah would get 2008 prices. Why, you ask?

In any Jewish community, there is a strong network of communication among families. Since children are about the same age and have many friends whose families are attending and planning mitzvahs at the same time, much information is shared. This makes for great referrals but also requires consistent pricing across the photography market.

Each synagogue has its own design based on its affiliation. For example, the one with the children is of Sephardic (Spanish) origin and has the bimah (reading pulpit) in the center of the synagogue. The synagogue shown on the facing page has a European origin, and its bimah is in the front.

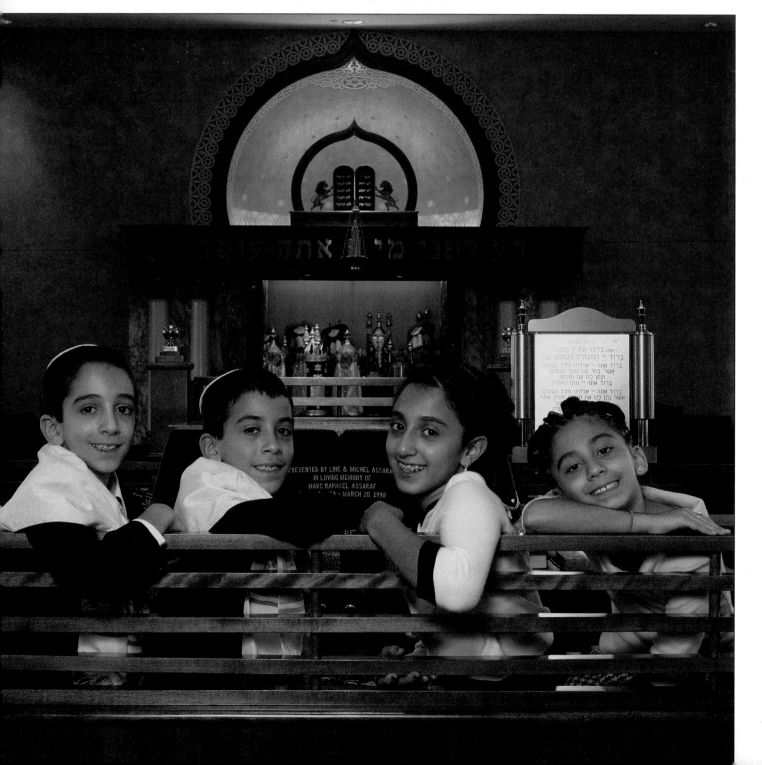

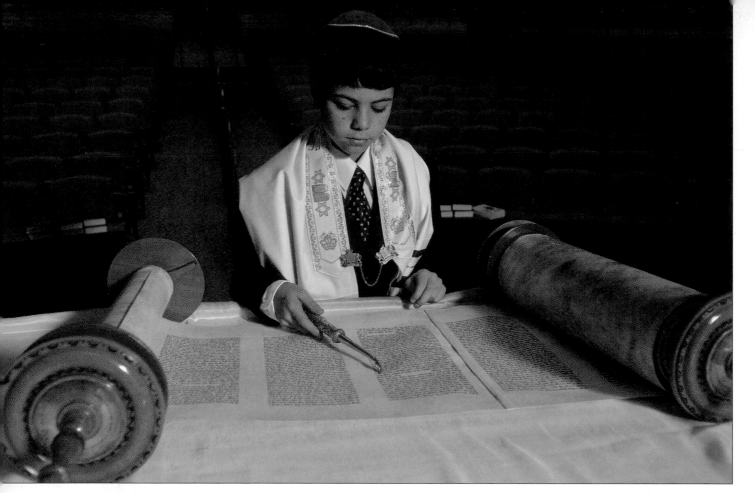

Since mitzvah dates are given two to three years in advance—and they are pretty firm—mitzvah families have some time to shop for services. If they have had other mitzvahs in the past, they will most likely work with some of the same vendors as well, assuming they had good experiences.

Mitzvahs take place throughout the year, with a few exceptions. All of this, and more, needs to be considered when marketing and selling photo plans to the mitzvah family.

Above—Notice the bar mitzvah boy is reading from the Torah, but there is no one else in the synagogue. This picture was taken mid-week, since photographing the service on the Sabbath is prohibited. **Facing page**—Photographing a bar mitzvah boy in his prayer shawl requires much attention to detail. Getting the collar to stay in place and getting the shawl to lay properly takes practice and patience.

MITZVAH TIMELINE

The mitzvah date is given to the child's parents by the synagogue committee two to three years in advance. The mitzvah coincides with the child's birthday according to the Jewish lunar calendar, not the secular calendar. For this reason, the mitzvah and the date of birth on the secular calender can be months apart.

Within six months of receiving the date, most parents will start the process of searching out and booking the key suppliers; a DJ and photographer are often the first to be booked based on demand and

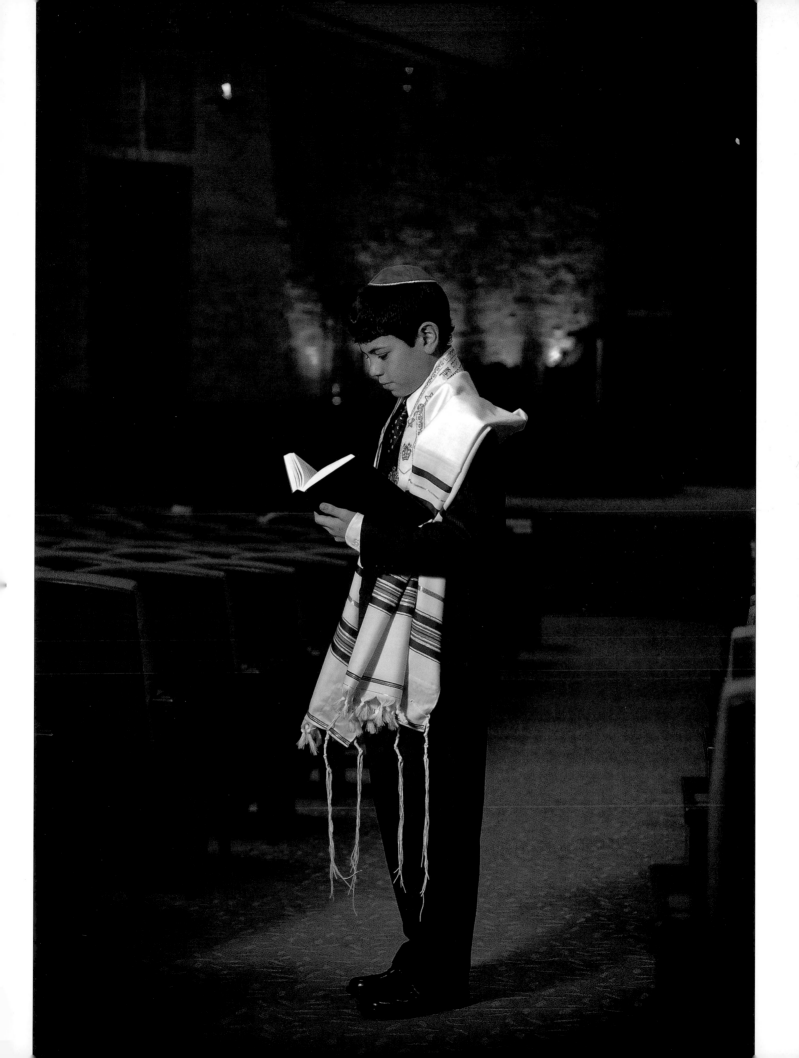

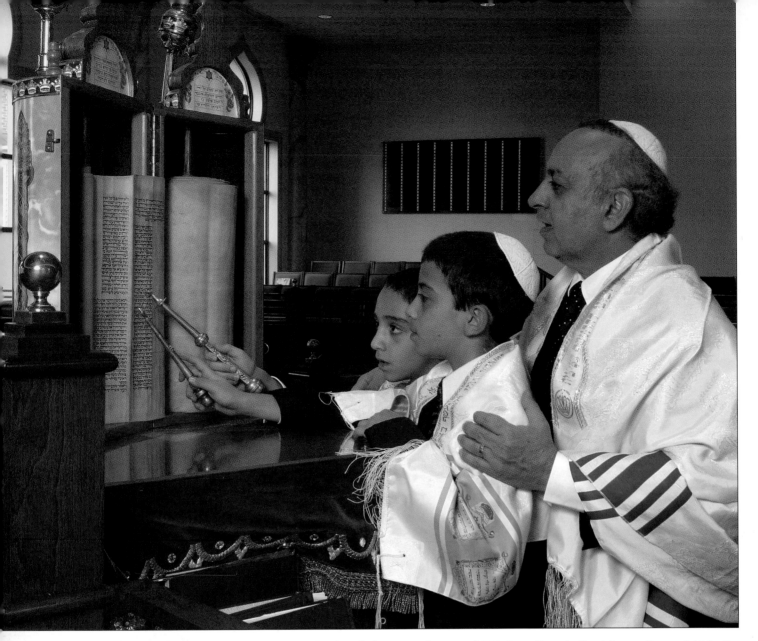

Note the Torah is standing upright for the reading. Sephardic Torahs, like this one, usually have a beautiful carved outer casing that protects the scroll.

reputation. While there may be hundreds of photographers and DJs in any given market, there are only a handful that specialize in mitzvahs.

Over the course of the year, other vendors are added. Within six months of the mitzvah, just about everything is booked for the event. It is rare to have someone call two to three months before a mitzvah to start booking vendors. If this happens, something most likely went wrong.

A month before the mitzvah ceremony, the photographer and mitzvah parents will need to schedule a day for the portraits at the synagogue. This is when posed portraits are taken in the synagogue, as well as a video recording of the child's reading from the Torah, if a video is purchased.

On the Thursday before the mitzvah, some families and synagogues have a tradition where the child leads the morning prayer service and puts on *teffilin* (black boxes with inscribed prayers and leather straps that are symbolic and worn during the morning service). This is not done by all families and is considered somewhat optional. The recent trend has been to add this tradition to give the mitzvah more meaning.

Each synagogue or temple has its own rules about any photography or video during the actual service, which falls on a Saturday. The only way to be 100 percent sure what is allowed is to contact the synagogue

Be sure to include siblings in the mitzvah portraits.

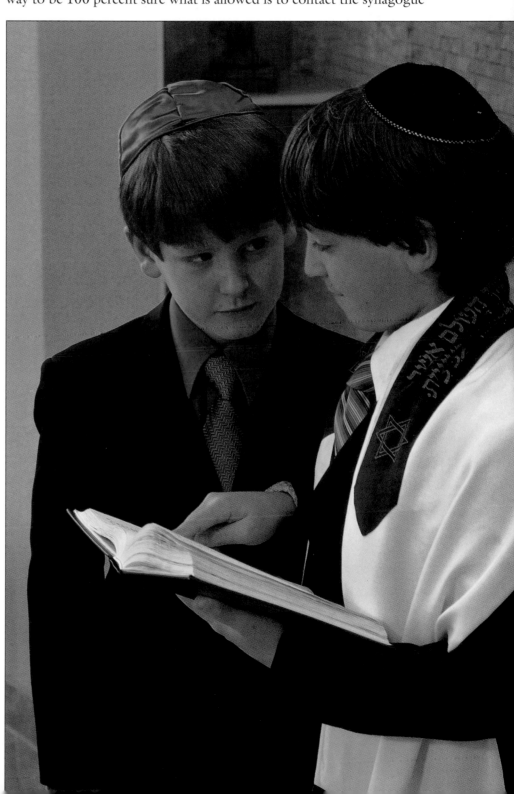

and ask. There is an executive director at each synagogue or temple, and he or she is responsible for all of the scheduling and guidelines for the day-to-day operations. You would not go to a rabbi for answers to these questions.

If you will be working with an Orthodox or Conservative congregation, then for sure no photography. Reform congregations are more relaxed and will allow photography during the Sabbath service—provided it does not interfere in any way—so in most cases, no flash is allowed and you may have to be off to one side and at a good distance. I have gotten some looks just because of the noise from my camera's shutter.

Following the Saturday morning service at the synagogue, it is customary to have a reception or party for the bar or bat mitzvah. This can take place that afternoon following the services or later that evening. These receptions are held in every possible venue, from the reception hall at the synagogue, a hotel nearby, a restaurant, or even at a ballpark or a museum rented for the evening. I have done them all. Since we live and work in Baltimore, I have photographed many mitzvahs on small yachts or chartered boats, with dance floors and all, that can host as many as two hundred guests.

With the restrictions of the Sabbath service, it has become customary to take formal portraits of the mitzvah child and family in the middle of the week just prior to the Saturday when the service takes place. This is typically done Wednesday or Thursday afternoon and is scheduled by the family with the synagogue. Occasionally a Friday session is scheduled to accommodate out-of-town relatives who are coming in for the weekend. Most synagogues try to prevent this, as they want to have the sanctuary cleaned and ready for the Sabbath service that Saturday morning.

The day after the mitzvah, some families host a brunch for out-of-town guests and relatives and may want to have a photographer on hand for a couple of hours to get additional family pictures. This is not included in most mitzvah photo packages.

The author's bar mitzvah picture taken forty years ago. Compare to the images shown on the facing page.

PREPARING TO PHOTOGRAPH

Attending a few bar and bat mitzvahs as a guest is a great way to observe firsthand what goes on during the actual service. The photographer can become familiar with what he/she may want to create during a portrait

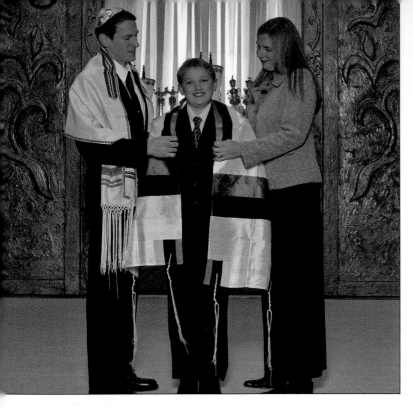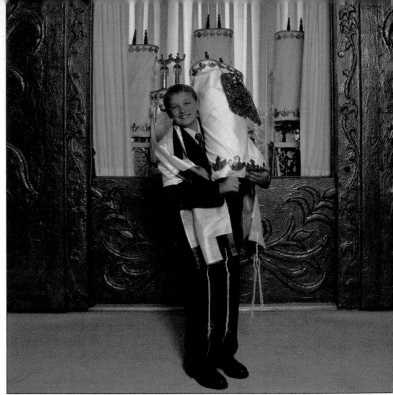

These images were taken at a bar mitzvah held last year at the same location as the author's bar mitzvah photo. Note the feeling that the images convey.

shoot. It is also helpful to visit different synagogues in the area to familiarize yourself with the architecture, lighting, etc. Though reading books and looking at photos can help tremendously, watching a bar mitzvah take place may provide the best education. Of course, being Jewish is a big help, but there are still differences among the Jewish sects. For example, if you are a member of a Reform congregation, there are bound to be some differences in a Conservative mitzvah that you will want to learn about.

I recently had the opportunity to photograph a bar mitzvah boy at the synagogue where I had my bar mitzvah over forty years ago. Look at the images shown above and on the facing page; though the photographs were taken forty years apart, both impart the feeling that this is a bar mitzvah picture. I can predict that the pictures will have much of that same feel fifty years from now too.

Now look at the next set of images (pages 22 and 23) and note how we can enhance the feeling with what I call the *Light of the Torah* images.

By now, you know there is good money to be earned photographing bar and bat mitzvahs. The degree of success you will enjoy is dependent on many factors, including your style of photography, your people skills, the way you present yourself, your business image, the amount of effort

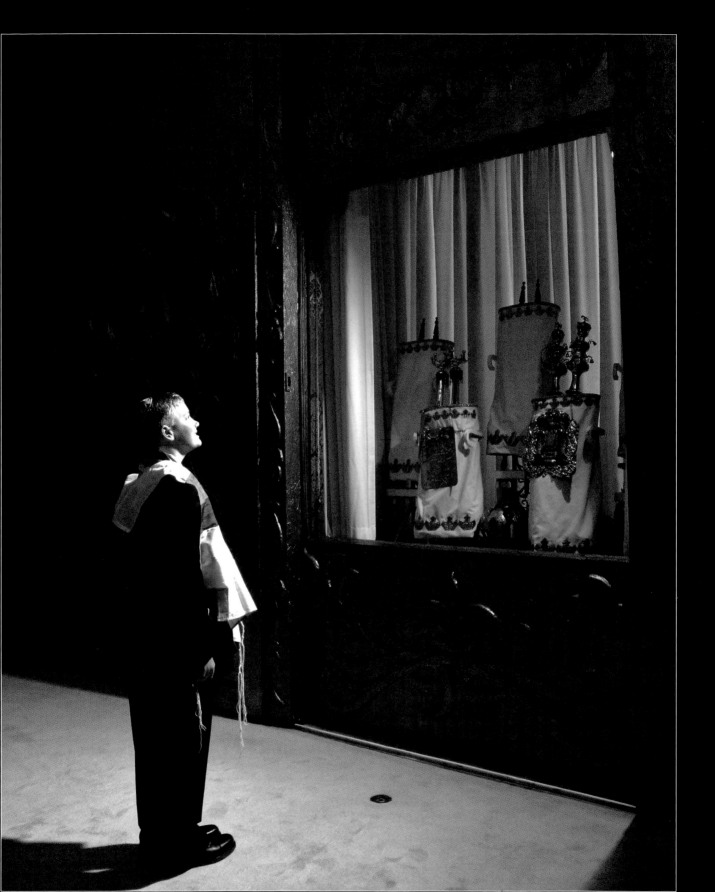

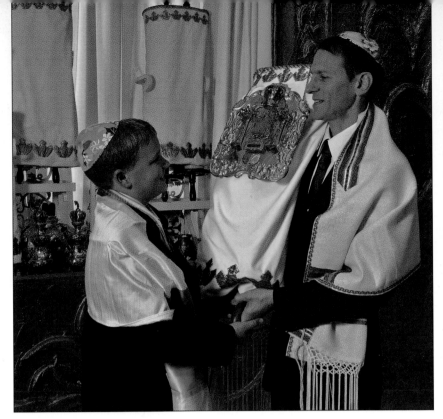
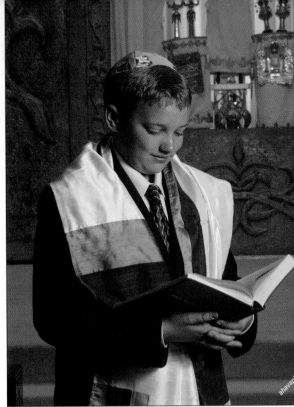

Facing page—I call this image *Divine Light*. **Above**—These images, as well as the image on the facing page, are part of my *Light of the Torah* series.

you put into marketing, your client service, and your handling of post-production. Notice that I did not include price, as I feel all of the other items must be considered before you consider your price structure.

Take care of all of the above and you will earn a valuable, well-deserved reputation in the Jewish community you are serving. Drop the ball on any of these, and word-of-mouth between families will kill your business potential before you know it.

This is one of the easiest demographics to identify and market to. Every family knows that they will have a mitzvah for their children when they reach the age of twelve (girls) or thirteen (boys). The kids all go to the same schools, and parents all ask the same questions, like who used who and what it cost, etc.

In the next chapter, we will look at marketing your photography to the mitzvah family. I've chosen to address marketing before turning to a discussion on the nuts and bolts of photography, as I believe you have to know what to market and who to market to before you can sell your photography skills.

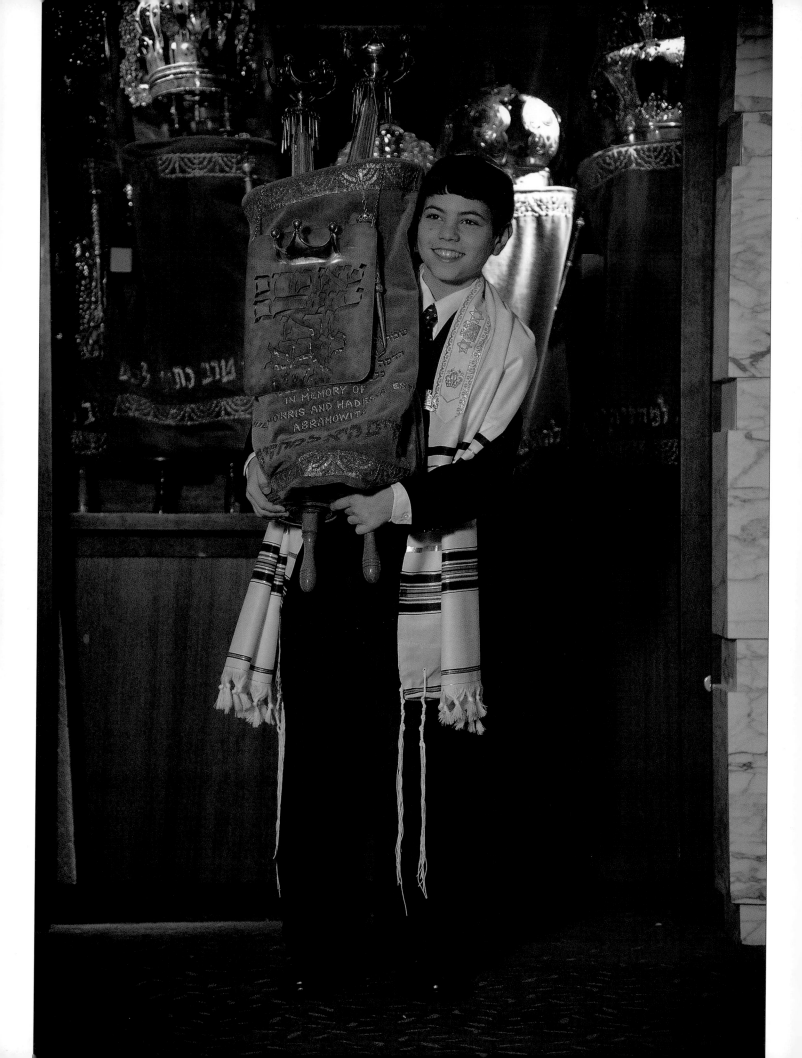

2. MARKETING AND SELLING TO THE MITZVAH FAMILY

This chapter may be the most important one you read in this book. Without marketing, you will have little, if any, business to develop. In the pages that follow, we'll answer some key questions that will allow you to effectively reach your target market:

- Who are the real decision-makers when it comes to booking a photographer for the mitzvah?
- What motivates a family to book your services?
- When is the best time to market to mitzvah families?
- Where are the best places to advertise your services?
- When is the best time to meet with the mitzvah family?
- Where is the best place to meet with the mitzvah family?
- What do prospective clients see as the biggest turnoff?
- What is the best way to get referrals?
- Who are your competitors?
- What helps sell your photo packages?
- Which marketing materials work best?
- Who spends the most money for reprints?

Facing page—The boy was instructed to hold the Torah at the bottom and not to wrap his arms around the front. Look how relaxed he appears holding a thirty-pound Torah.

The key to marketing is to understand who you are marketing to and what their needs are, real and imagined. Let's first turn our attention toward learning about the mitzvah family.

SO, WHO ARE YOU MARKETING TO?

The typical mitzvah family has a child who attends some type of Hebrew study program (Sunday school) and is affiliated with a congregation. These two factors are a given, as the child is required to be tutored to read from the Torah in Hebrew prior to the mitzvah.

Even with the number of interfaith marriages, it is likely that one of the two parents had a mitzvah themselves. This is important to keep in mind, as the experience they had at their own mitzvah has a lot to do with what they plan to do for their own child's mitzvah.

Home page (top) and web page album show (bottom) of web site with menu options running across the bottom.

The mitzvah family knows from the day the child is born approximately when they will become a mitzvah. How's that for long-term planning?

When it comes to budgets and expenditures for the mitzvah, they will most likely go over budget and spend more than they intended to. This is even more common if this is a bat mitzvah. By the way, there are more bat mitzvahs than bar mitzvahs, as there are more girls than boys. When you look at the number of line items in a mitzvah budget, it is easy to see how they can add up to $15,000–$25,000 affairs.

Photo services will be very important to the mitzvah family, since they will want to have family portraits of this milestone for themselves and for the grandparents, who are a big factor in determining what they will spend for pictures. It is common for grandparents to help out with some of the expenses, and their contribution usually ends up going toward the photography or video.

Again, keep in mind that there is much communication among families that have children reaching mitzvah age in the same year, so your marketing mistakes will be spread through word of mouth from family to family, without you even knowing it. For this reason, if you are to make changes in your marketing, pricing, etc., small changes are warranted.

I TRY TO INCLUDE THE CHILD IN THE MEETINGS WHEN I KNOW THERE WILL BE A BAT MITZVAH.

IMPORTANT QUESTIONS

So let's answer some of the questions that will help you create and launch an effective marketing approach for participating in the mitzvah market.

Who are the real decision-makers when it comes to booking a photographer for the mitzvah?

The mother will be doing much, if not all, of the information-gathering and planning with vendors. As long as budgets are within reason, she will often make the selection regarding who to use. Female mitzvahs, however, typically have some say in choosing the photographer. This is one of the reasons why I try to include the child in the meetings when I know there will be a bat mitzvah. Showing her albums that she will want and going over details of what is planned is very important in order to have her work on your behalf after the consultation is over.

So, if it is to be a bat mitzvah (65 percent are), be sure to try and have the child as part of the consult. This can make the difference between you and another photographer.

What motivates a family to book your services?
Though we would all like to think it is our masterful imagery that gets us the bookings, the fact is, mitzvah families are often swayed by what I call the "comfort factor." Though attractive images are important, the mitzvah family must feel comfortable with you and your level of confidence that you can give them what they want. There are likely several photographers who will have similar expertise as you, so it is the way that you come across to the family that will encourage them to book you for the job.

Much of the feedback I receive after the mitzvah has to do with how we work, how professional we are, and how unobtrusive we are. In fact, I always ask a family what they think they will remember the most about the images or the person who took the images ten years from now. I always get some kind of story about how their wedding photographer was pushy or loud. The experience these families had with the photographer made more of an impression than the photos.

With this said, your entire marketing approach should be one of a relaxed nature, providing guidance, good advice, and a feeling of confidence. My experience has been that if I meet with a family, seven out of ten times I will book them. With all things being equal—the quality of your photography, the pricing, and what you offer in your packages as compared to others in your area—you will always have the advantage if you master the "comfort factor."

IT IS BEST IF YOU CAN HAVE BOTH PARENTS AND THE CHILD PRESENT AT YOUR MEETING.

When is the best time to market to mitzvah families?
Remember, mitzvahs take place year round. Summer months are usually the slowest for new bookings, while spring and fall are the busiest.

You will find that most Jewish communities have vendor fairs or showcases for mitzvah families to attend early in the year. These are hosted by large synagogues or publishers of mitzvah guides such as the *Bnai Mitzvah Guide* (www.bnaimitzvahguide.com). Though these are good shows to attend, it is the direct-mail follow-up after the show that keeps your services in the minds of the mitzvah family.

YOU WANT THE CHILD TO WORK ON YOUR BEHALF, SO BE SURE TO GET THEM INVOLVED.

Where are the best places to advertise your services?

Special publications like mitzvah guides and local Jewish magazines such as *The Baltimore Jewish Times* have sections for vendor advertising. One excellent medium for advertising at a great rate are the monthly newsletters the local synagogues send to their congregants. Running an ad in these publications will typically cost $50 to $100 a month. Of course, many families will search for vendors on the Internet, so web advertising and having a great web site to showcase your work are essential.

When is the best time to meet with the mitzvah family?

It is best if you can have both parents and the child present at your meeting. I find that the best time is in the evening after dinner at the family's home. Sunday afternoons may work for some families, but you may find that you are working or the family has other obligations.

Where is the best place to meet with the mitzvah family?

Meeting at the family's home has some distinct advantages, as they do not need to deal with the hustle and bustle of packing the family into the car and traveling to your location. Today, many photographers cover a large region; in this case, it is courteous of you to travel to them to host your meeting.

What do prospective clients see as the biggest turnoff?

Though some photographers feel differently, I think that asking a family to book your services while you are meeting with them can be a big turnoff. I have a very relaxed method of selling to the family. I always tell them they don't have to make a decision on the spot, and I encourage them to talk amongst themselves. This doesn't mean I don't book the families during the meeting—I often do—I just don't actively push for the booking.

Arriving late—and also arriving early—to the meeting is another turnoff. Why? Think of the mother. She wants to be ready for you, and she is sure to feel more comfortable if you are running on schedule.

Last, but most important, do not ignore or talk down to the mitzvah child. In fact, be sure to ask if they have any questions they would like to ask of you. These are pretty sharp kids, and they will form an opinion about you that they will share with their parents. You want the child

to work on your behalf, so be sure to get them involved with questions about the party theme and what kind of photos they like the best.

What is the best way to get referrals?
This has been said many times, but it's worth repeating: network with other vendors that serve the same industry. DJs, balloon vendors, caterers, and venue staff will all help you. In addition, posting the mitzvah images online for friends and relatives is a great way to get referrals. Make it easy for your past customers to refer you by giving them plenty of business cards to share with their friends and family.

Who are your competitors?
There is a growing and alarming trend taking place in the mitzvah industry: today, DJs and entertainment companies are offering complete packages that include invitations, decorations, party favors, music, dancers, light shows, photography, video, photo booths for snapshots—you name it. *(Note:* The dancers are typically high school or college students who dance with the kids and keep the party lively; they may also help with a candle lighting, etc. They do not perform ritual dances but may break-dance as part of the entertainment.) They know that the family has a budget they are working with and want to get as much as they can for their money.

The more package options the family buys, the greater the discount. For families that have little planning time or are on a tight budget, this is a consideration. As one mother told me, "It is not the quality as much as what can I get for my dollar that I am interested in."

The competition from such companies is tough in some markets, and it is a factor you must take into consideration when marketing to these families. These do-it-all vendors tend to fall short in serving clients after the event. Be sure to explain that by reviewing the photo selections and album options with the family, your service will be so much better than what they will get from a DJ company that outsources the photography.

THESE DO-IT-ALL VENDORS TEND TO FALL SHORT IN SERVING CLIENTS AFTER THE EVENT.

What helps sell your photo packages?
Your photo packages must be geared specifically to the mitzvah client, and the features and wording should suit this market. Sign-in books,

thank-you cards with the mitzvah child's image, and canvas prints are big with mitzvah families. Graphically designed, magazine-style albums are great for mitzvahs; be sure that this is one of the album styles you offer.

What kinds of marketing materials work best?

In this day and age of on-demand print services and desktop publishing, it is easier than ever to produce marketing materials that are worded and geared just for the mitzvah market. A generic piece that includes wedding, portrait, and any other photography services cannot compete against a marketing piece designed just for the mitzvah market.

Our studio, Ahava Photography, has gone as far as creating separate brands for each market segment—Ahava Mitzvah Photography and

The mitzvah album is the biggest profit-generating product photographers offer. Here we see a sample acrylic album cover, which features a black leather spine. Some album spreads are shown in the pages that follow.

RYAN JACOB LESSING

JUNE 14, 2008

Above and facing page—Here are some sample spreads from a mitzvah album.

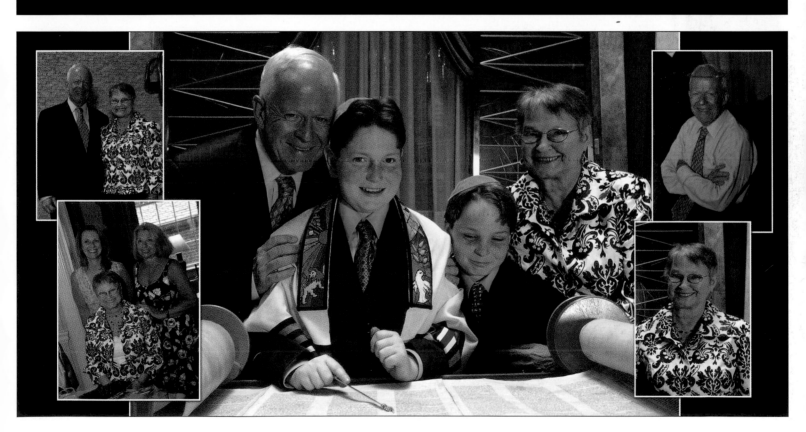

Ahava Wedding Photography. Each of these brands have their own web sites, marketing materials, and client documentation. They are truly separate in every way.

Who spends the most money for reprints?

Post-mitzvah print sales are not a great source of revenue since the family has likely used up its budget for the event. Yet, there is still an opportunity to sell to family members using one of the web sites that will host your images and fill print orders. Our biggest customer for reprints has always been grandparents.

IN SUMMARY

There are many valuable books available on the subject of marketing; however, you must be sure to tweak the recommendations to suit your target audience. Be sure to talk to the vendors you meet to get information about trends in the market. Also, ask past customers what they liked the best about you and why they booked with you, other than price. You might also consider sending a survey to past customers asking them to rate your performance on things like service, quality, etc. Getting feedback is the key to effective marketing; it will not only help you find out what works and do more of it, but it will also help you determine what isn't working. When trying to fine-tune your business, remember that making small changes is best, and that any new practices should be measured for effectiveness.

BE SURE TO TALK TO THE VENDORS YOU MEET TO GET INFORMATION ABOUT TRENDS IN THE MARKET.

3. INSIDE THE SYNAGOGUE

Synagogue portraits are the reason why families hire a professional to photograph their child's mitzvah. Because it takes a good deal of understanding and creativity to produce images that reflect the significance of the mitzvah ritual for the

family, few photographers are successful with mitzvah photography. This chapter will cover all aspects of photographing the mitzvah child within the synagogue, including the religious articles used in the service and poses that reflect the meaning of the day, arming you with the information you need to succeed.

A SPECIAL NOTE

All synagogues prohibit moving equipment or tables around. Photographers have been restricted from working in certain synagogues for this reason alone. Be sure that you, and any assistants you may be working with, are aware of this before beginning the session.

THE FOUR DENOMINATIONS

It is helpful to have a basic understanding of the types of synagogues you may find yourself working in. Among Jewish congregations, you

will find four denominations, all of which are very similar with respect to the buildings and religious articles used. Their major differences will be seen in the customs practiced during worship (for example, Orthodox synagogues have separate seating for men and women) and the actual prayer services held.

The following information will help you understand some of the differences between the Jewish affiliations and how these may affect your photography. Keep in mind that each synagogue will have its own guidelines regarding what they will or will not allow during a photo shoot within the synagogue. It is always good to ask beforehand if there are any special limitations, as you will not want to be blacklisted from working within a synagogue for violating one of their rules.

There is also a requirement among many synagogues that they must have a copy of the photographer's liability insurance coverage on file before they will allow you to work on the premises. This is for their protection, and as a business owner, you should have this as well.

Ultra Orthodox Congregations. Ultra Orthodox families represent an extremely small potential market for mitzvah photography. The reason for this is that girls do not have a bat mitzvah ceremony and boys typically will lead a service and then have a small family gathering or a party just for friends.

Modern Orthodox Congregations. Modern Orthodox families celebrate both bar and bat mitzvahs, but because they are still Orthodox families and maintain that girls do not read from the Torah, the actual religious ceremonies are unique. Typically, the boy will become a bar mitzvah as part of the services held Saturday morning where he will read from the Torah. That afternoon following the service, or that evening, the party will take place.

For the girl, a service is usually held Sunday morning. The bat mitzvah girl recites some prayers or scripture but does not read from the Torah. She also does not wear a teffilin or tallit. Note, therefore, that you should not plan to incorporate these items in the photographs.

The party takes place following the service. There can be times when the girl will have her party on Saturday night and will then have services on Sunday morning.

Conservative Congregations. In the United States, Conservative Judaism accounts for 27 percent of the Jewish households affiliated with

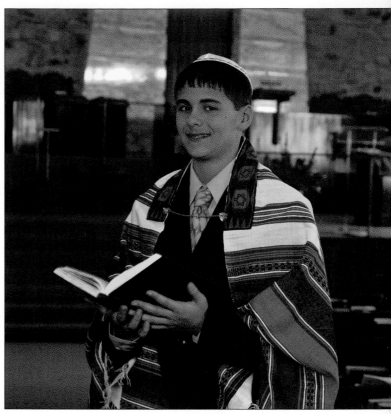

Left—This bat mitzvah is not reading from the Torah and is not wearing a prayer shawl. **Right**—A bar mitzvah in the same congregation wears a prayer shawl and reads from the Torah.

a synagogue, and Reform Judaism constitutes 26 percent. These two movements represent a good 90 percent of the mitzvah business.

In a Conservative synagogue, men and women have equal religious duties. Woman are allowed to become rabbis. A bat mitzvah girl reads a section from the Torah like the bar mitzvah boy, and both will wear a tallit during services. It is customary that only the males will wear a teffilin, but there are some women who do since there is no official restriction preventing them from doing so.

So here we have girls and boys both called to read from the Torah during the services on a Saturday morning, with celebrations held later in the day. Since there are more girls in the community, you will find that more bat mitzvahs take place.

As far as photographing a bat mitzvah girl, there is no difference in the pictures taken as compared to a bar mitzvah boy, other than the type of poses that work best for a particular gender. The bar and bat mitzvah will perform the same rituals, and therefore their photographs should be of the same nature.

This image was taken during the service from a balcony so as not to interfere with the service. Many synagogues have upper balconies that are typically only used during high holiday services, when they are filled to capacity. During the rest of the year these remain vacant and make an suitable—though distant—location to shoot from.

Reform Congregations. Here again, we have equality among the boys and girls of mitzvah age. The same guidelines are followed with just a couple of minor differences. In the Reform synagogue, it is not mandatory that the men wear a head covering or tallit. This also applies to the women, and you will find bat mitzvah girls may or may not wear the tallit. This is essentially left up to the family.

The service is very similar, and there is reading from the Torah, but the reading is more condensed and has more English (versus Hebrew) in the reciting of the prayers. The same photographs taken at the Conservative mitzvah would also apply here. There is the potential that you may photograph and videotape the service from a remote location during the service, as many reform synagogues allow this. Of course, this is very limited and does not offer the flexibility of posing subjects, working with lights, etc.

The family may also ask that you take portraits prior to a service on a Saturday morning, as most Reform synagogues allow this. You should try to convince them not to do this for several reasons:

- They will most likely show up late (getting dressed, kids, etc.), which will give you very limited time to get any good work accomplished.
- The child will already be stressed, knowing that he/she will soon be reciting something to a large group of people. This anxiety will make it hard for the child to relax for the portraits.
- Some guests may start to arrive and give hugs and best wishes, which will distract everyone. You will not be able to focus on your work, as you will be worried about crowd control.
- This may be a double mitzvah, with two children sharing the service. If the other family had the same idea to take portraits, you will be competing with another photographer for space and time.

Trust me—all of this has happened to me, and all at the same time, and it was no picnic. Do the best you can to talk the family out of taking photos before the service. If you can't, get as early a start as you can to allow for maximum time. I guarantee that you will need it.

NONAFFILIATED FAMILIES

Today, you will find many families that are not affiliated with any synagogue and rarely attend religious services but still want their child to have a mitzvah ceremony and the celebration that accompanies a child becoming a mitzvah. As a result, there are tutors that will work with the child over the course of the year preceding the mitzvah to help prepare them for the upcoming event. Additionally, these tutors will provide a Torah and lead services at a venue such as the country club, hotel, or even at the family's home. This private service does not require the family to belong to a congregation and, for many families, this is an alternative to joining a congregation.

There are many religious leaders who are against this practice and do not feel it is in the spirit of what a mitzvah for a child should be. They equate this to cramming for an exam or taking some type of shortcut.

I myself find these private services quite moving and feel that they offer the children the opportunity to have a mitzvah, which may not happen any other way.

Taking pictures is not a problem at these private services, provided no flash is used and the photographer remains out of the way.

IN THE UNITED STATES, CONSERVATIVE JUDAISM ACCOUNTS FOR 27 PERCENT OF THE JEWISH HOUSEHOLDS.

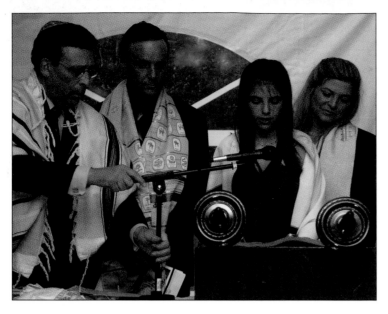
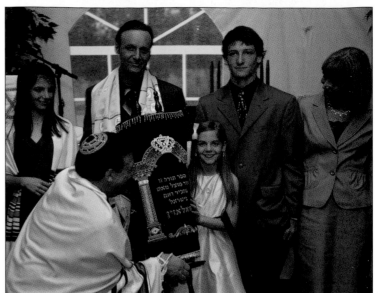
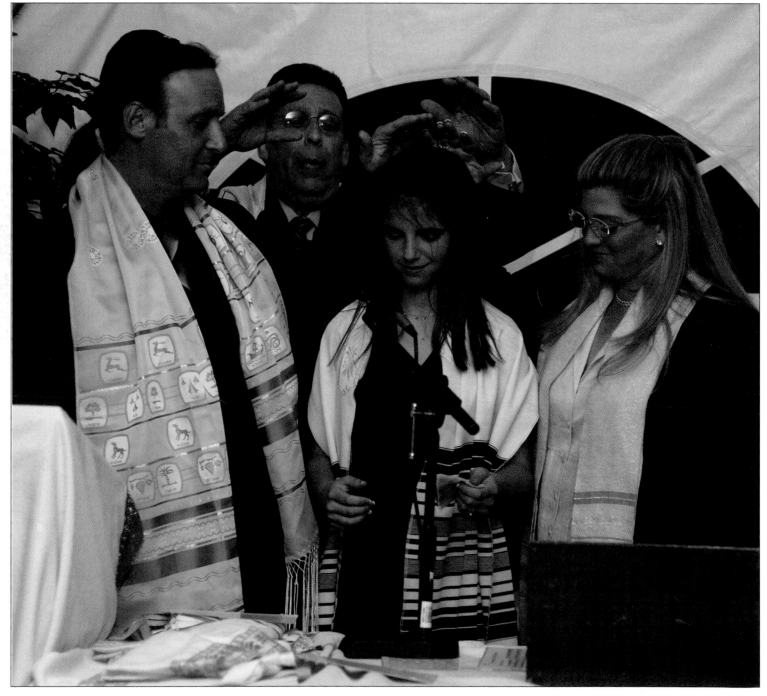

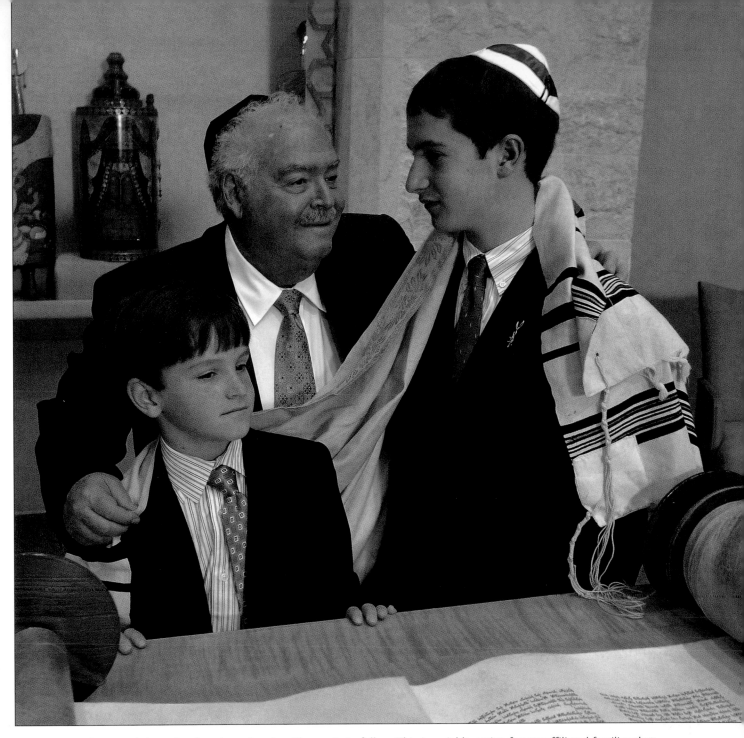

Facing page—Country club service for a bat mitzvah, with a party to follow. This is a viable option for nonaffiliated families that want to follow the Jewish traditions. **Above**—This tallit is over one hundred years old and survived the Holocaust. Making use of it for an image is priceless for the family.

RELIGIOUS ARTICLES

Within the synagogue there are many religious articles and symbols that are associated with a bar/bat mitzvah. Many are used during the mitzvah ceremony as well. During any portrait session with a mitzvah family, you will be expected to make use of, and incorporate, these elements

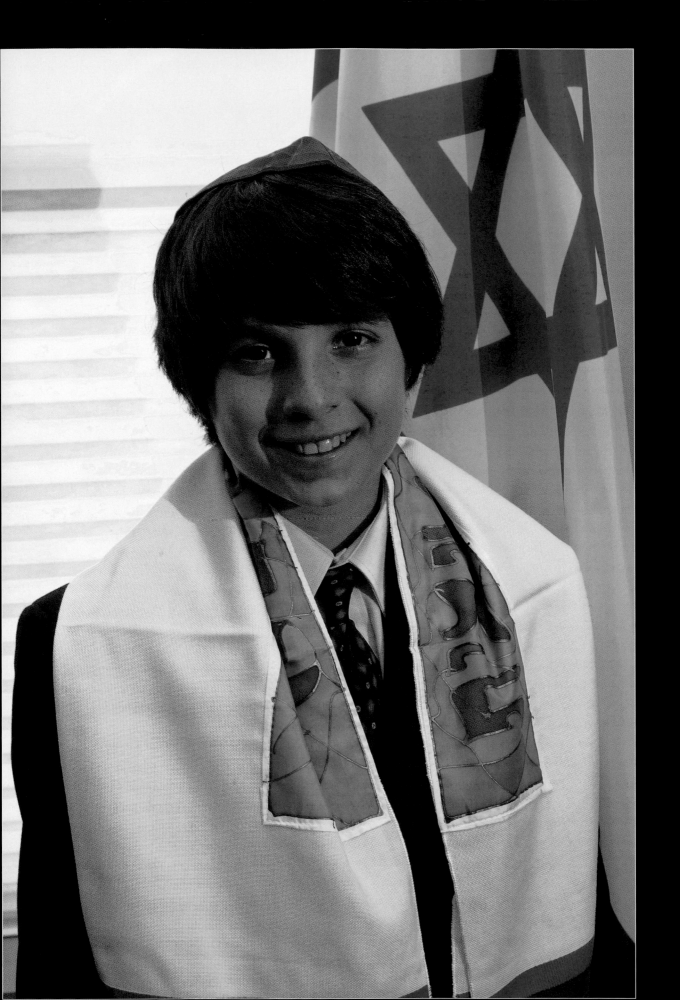

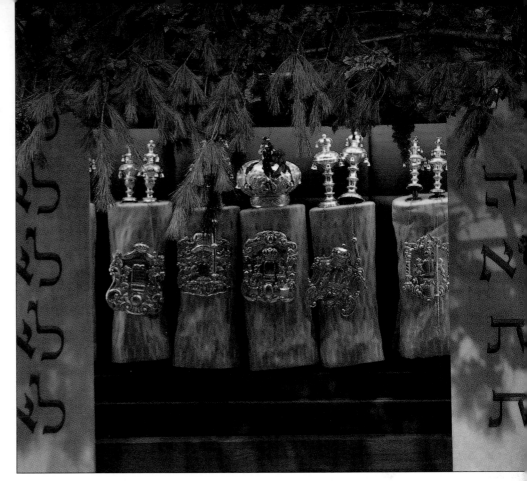

Facing page—The flag of Israel may not be a religious symbol, but it helps create a feeling of belonging to the State of Israel, the homeland of all Jews. **Right**—A beautiful photograph of the ark can be a great addition to the mitzvah album.

in your photographs. This gives extra meaning to your images, and your skill in making use of these items in your photography will help establish you as a true mitzvah photographer.

Many of these items are photographed alone as detail shots to be used in the design of an album as well as with the family using them during a ceremony or custom. Keep in mind that many of these items have been handed down through generations, and they may have even survived the Holocaust. Be sure to ask about any heirlooms that must be included in the photographs.

The Torah. The Torah is a handwritten parchment scroll containing the five books of Moses (Old Testament). It is one of the most religious articles in the Jewish faith. All synagogues have a Torah and will make use of it during services. Because the text is handwritten by a scribe, production can take several years to complete, and the resulting Torah can cost several thousand dollars. Torahs are well protected in an *ark* (a wall opening or decorative cupboard in the front of the sanctuary which holds the Torah scrolls) and are taken out only during services.

The mitzvah child will read from a Torah during the actual service on the day of their mitzvah. Having photos of the child reading from the

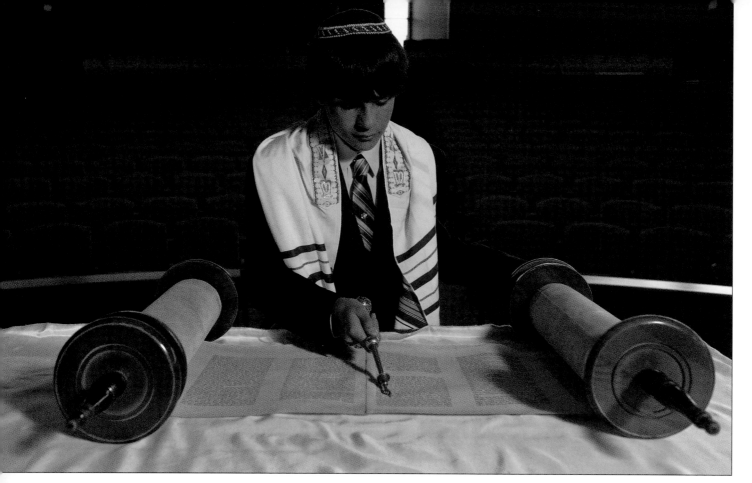

Torah is very important for the mitzvah family. Because you will not be able to photograph this during an actual service (there is generally no photography on the Sabbath), portraits with the Torah are often taken at the synagogue midweek. Which Torah can be used varies at each synagogue, and you will need to ask the synagogue administrators what can be used and who needs to assist you with the Torah. Surprisingly enough, there are some synagogues that are very lax about using a Torah and let you have free use of the ones in the ark. Others may have a Torah that has been made with just some of the parchment and text to be used for pictures only. These Torahs are not suitable for use during an actual service.

The Torah can be very heavy, as parchment weighs a lot and Torahs are usually big and bulky. You will need to be careful if you are working with a kosher Torah, as it is a big deal if you should drop one. Additionally, you are expected not to touch any part of the writing with your hands or any items other than a *yad* (a pointer made of silver, wood, or glass that is used to guide the eye in reading from the Torah). Some are plain and some are very fancy. If this is a gift from the parents or grandparents, then you will want to be sure to incorporate it into your

The Torah may be photographed for mitzvah pictures, but there are guidelines that must be adhered to. Always ask for permission before doing anything with a Torah.

photos in a creative style. If any letter in the Torah should become damaged (scratched by your lens or something), then the Torah is no longer kosher and cannot be used during a service. For these reasons, there are many synagogues that will have a person assist you with the Torah.

There are several images commonly taken with the Torah. Some show the Torah open for reading, others have the Torah closed and dressed. You might take photos with the mitzvah family holding the Torah and capture some images showing a bat mitzvah in prayer.

Helpful hints for working with a Torah:

• Always remember that this is a religious object and must be treated with the utmost respect. Never take a Torah from the ark without permission, and be sure to ask which Torah should be used for the photos.
• When using a Torah, do not touch the letters written on the parchment. For that matter, don't touch the parchment except to place the Torah on the reading table. Be sure to tell the mitzvah family and child to keep their hands off the Torah too.

Here a tallit, yad, and Torah make a nice combination for a very meaningful mitzvah image.

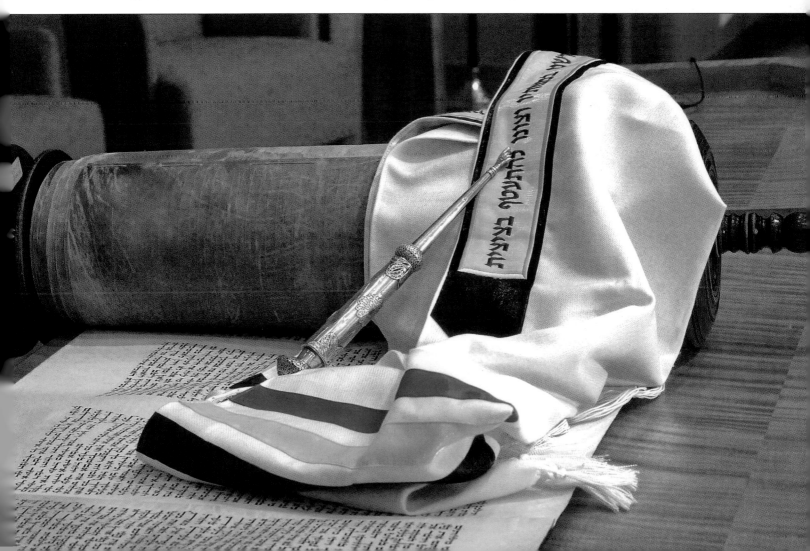

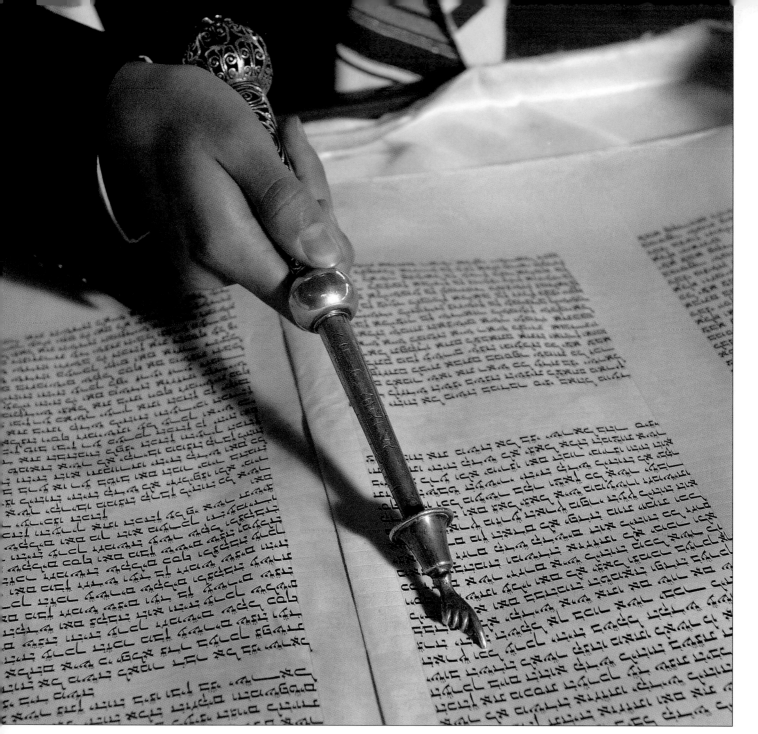

• Torahs are heavier than you might expect. Always pick them up slowly with two hands, as they are covered with a cloth dressing that may make the Torah slip around in your hands.

• Keeping a Torah open (rolled out) for reading can be tricky. The best way to prevent the Torah from rolling up without obstructing the ideal angle of view for pictures is to place four unused tan ear plugs in the corners of the wooden handles the Torah is wound upon.

This photograph of a child reading from the Torah with a yad shows us how the Torah looks to the mitzvah child while reading. Note the Hebrew letters, which the child must learn to read before the mitzvah day.

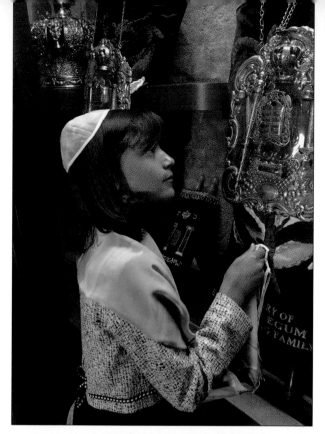

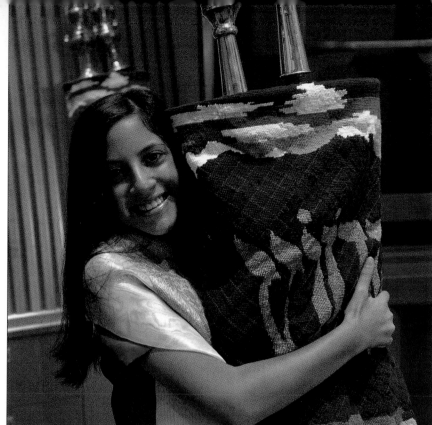

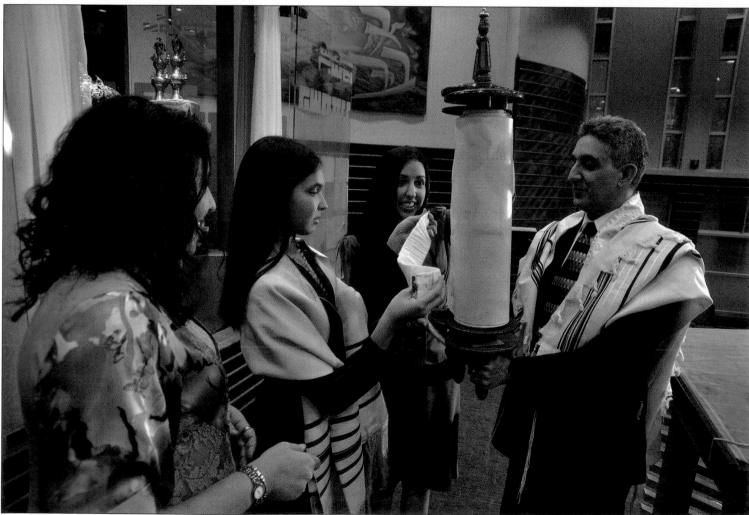

Top left—This image of a bat mitzvah looking up in prayer while touching a Torah invokes the feeling of part of the mitzvah ceremony, as the Torah is put away at the end of the reading service. **Top right**—A photograph of the mitzvah child holding a Torah is a must-have image for any mitzvah family. The key here is to have the child look relaxed without straining under the weight of the Torah. **Bottom**—Having a family work together gets siblings involved and creates the opportunity for a beautiful, spontaneous image. Stay out of the action and let them work together.

- Never let a child pick up a Torah on their own! When the child is holding a Torah for a picture, a parent *must* stand within arm's reach to prevent any mishaps.
- Torahs must be rolled back into the same place where they were opened from, as this is where the week's reading will take place.
- A Torah must be put back in the ark from the same location it was taken from. There are several Torahs in the ark, and they are placed in a particular order. Do not move any of them around, period.
- Be sure to bind the Torah together with the *wimple* (a piece of material used to hold the scrolls of the Torah together) before having the cover put on.
- Be sure to put all ornaments back on the Torah correctly. This includes the breastplate, crowns, yad, etc.

Facing page—A yad is a pointer used to read from the Torah. It makes for dramatic images when held in the hands of a mitzvah child.

As you can see, there are many requirements when working with a Torah. Over time, you will become comfortable using a Torah in your pictures. Don't let these guidelines prevent you from using your imagination to create dramatic pictures.

Torah Accessories to Photograph. Torahs are always dressed in a covering and have ornaments placed on them that are meaningful and quite artistic in design. You will want to have detail shots of these items, which can be used in your album design, and these photos also serve as cherished memos for the mitzvah family. Keep in mind that this will be one of the few times that many families are this close to a Torah.

Yad. The yad is a special tool that is used in keeping one's place while reading from the Torah. It is usually made of silver, gold, or bronze but can also be made from wood, glass, ceramics, and other materials.

Most of the time, you will find a yad on a chain hanging on the Torah. It is removed when undressing the Torah. Some synagogues may have a yad placed under the table from which the Torah is read. In some cases, a yad is given to the child as a gift from a parent or grandparent, or it may even be a family heirloom passed through generations.

You will want to make use of the yad in your images, and there are several ways to do this. The following images show some of your options for photographing the yad.

Wimple. The wimple is a hand-crafted cloth that is used to bind the Torah together. During the 1500s, the custom of taking the cloth used

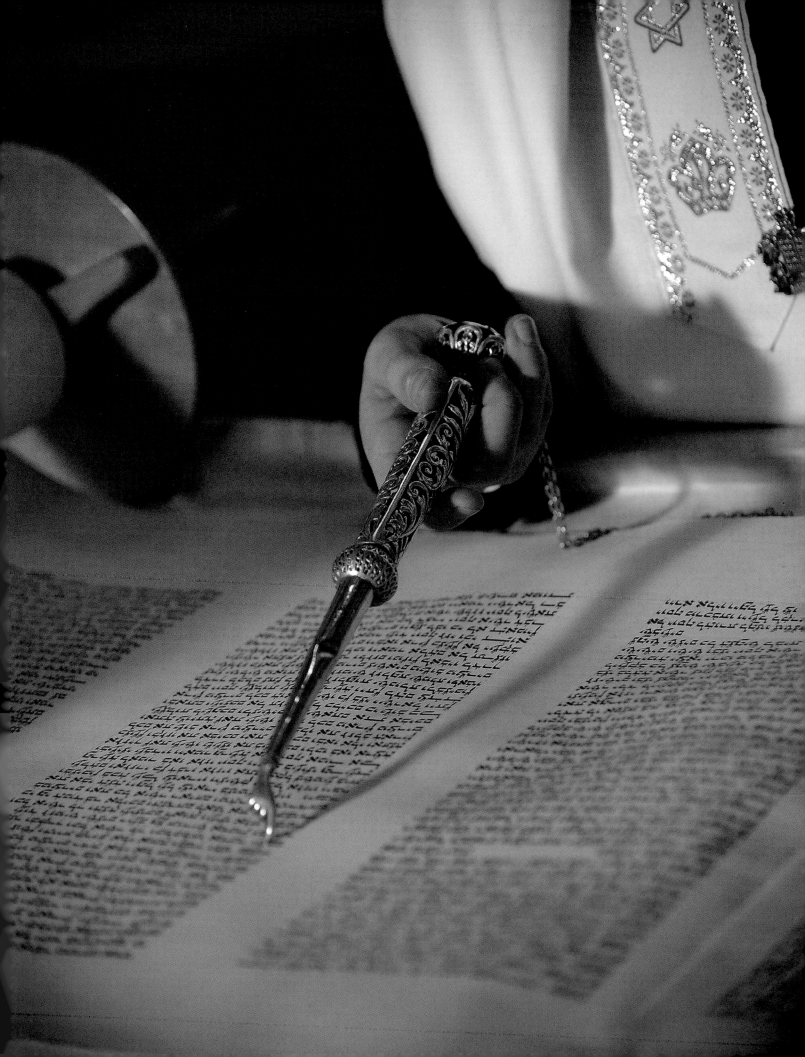

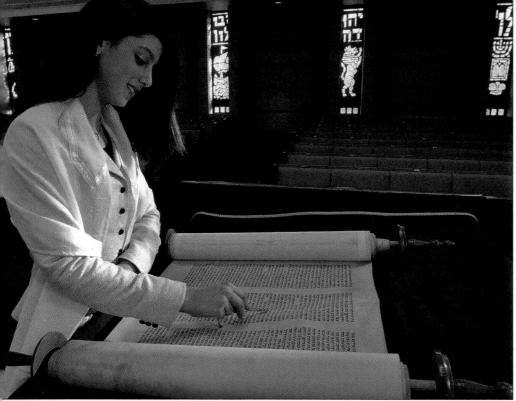

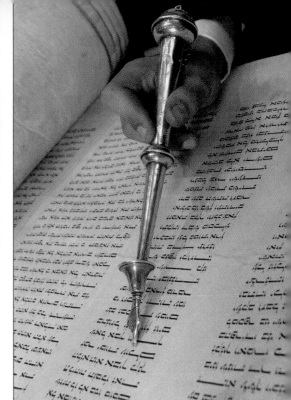

Be sure to ask the family if they have a special yad they will be using. Such an image can make a great detail shot for the album.

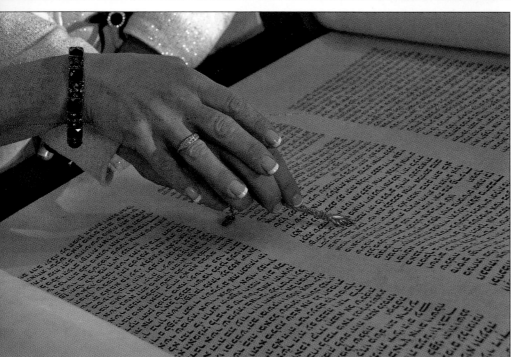

to swaddle a male child at his *brit milah* (circumcision) and embroidering the child's name and mitzvah date upon it began. There are wimples on display in many synagogues that are several hundred years old.

Today, the custom of making a wimple is experiencing a rebirth, and it is an article that is commonly used in the mitzvah service, as many mitzvah families are looking to tradition for ways to add meaning to the

mitzvah ceremony. Ask the family if this will be part of their custom for the child's mitzvah. If so, you will want to incorporate the wimple in some images.

Torah Dressing. In addition to the yad, there are several items that are considered to be part of the dressing for the Torah. These are also symbolic and are great subjects for detail images to be used in a mitzvah album design.

These items are representative of the garb worn by the high priest when he served G-d in the sanctuary of the holy temple in Jerusalem.

The actual parchment is wrapped around a wooden frame called the *etz chayim* (tree of life). These wooden handles are used for holding and scrolling through the Torah. During the course of your work with the Torah, you should only use the wooden handles to posi-

Left top and bottom—Using a wimple to bind the Torah is an old custom that is becoming popular again. The wimple is hand-made with the mitzvah child's name and mitzvah date. **Right**—The dressed Torah is representative of the garb worn by high priests in the holy temple in Jerusalem. Note the crown on top and the breastplate with the twelve tribes of Israel represented.

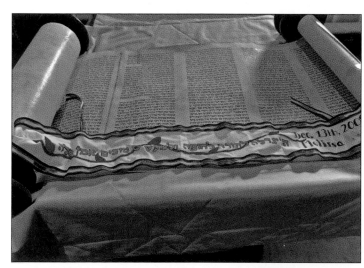

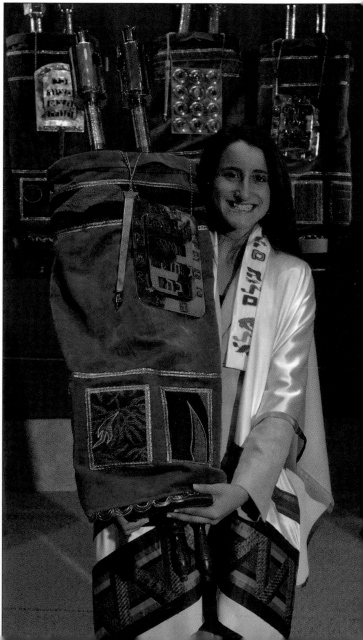

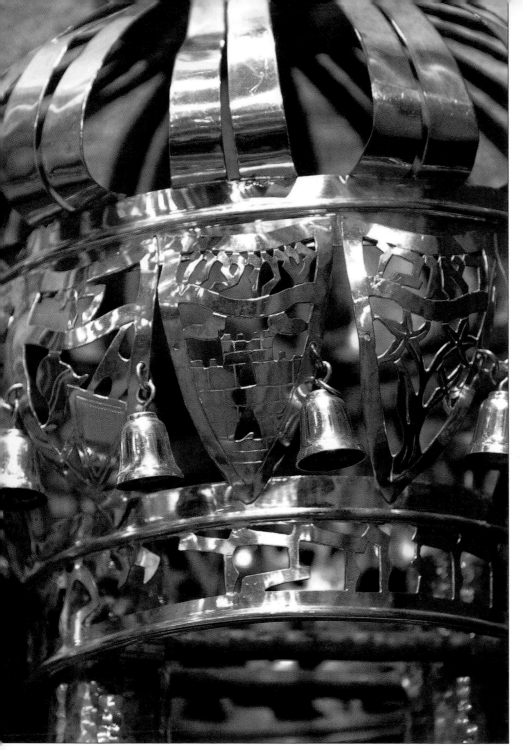

Torah crowns make great detail images that can be used in the design of an album.

tion and move the Torah. Also, when dressing the Torah, it should be put back together the way it was found.

Tefillin. The tefillin are a pair of little boxes that have leather straps attached containing parchment inscribed with biblical verses. One is placed on the hand and the other on the forehead. The tefillin are closely associated with a bar mitzvah as Jewish males are obligated to put on tefillin starting at the age of thirteen. The tefillin are worn during morn-

ing services on all days except Sabbath and select holidays. This is more prominent among Orthodox males and is not required of women.

It is customary for some families to have the mitzvah child (mostly males) read from the Torah during the morning service on the Thursday before the Saturday they will be called to read from the Torah. Since this is a weekday morning service, the child wears tefillin, and you may be asked to photograph this on the weekday. Note that this is an early

Wearing tefillin at the morning service (but not on Sabbath) is a requirement of all Jewish males from the age of thirteen. For this reason, it is closely associated with bar mitzvahs.

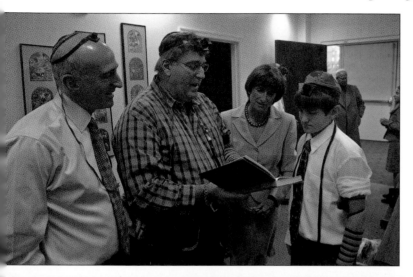

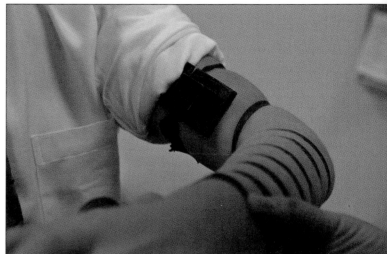

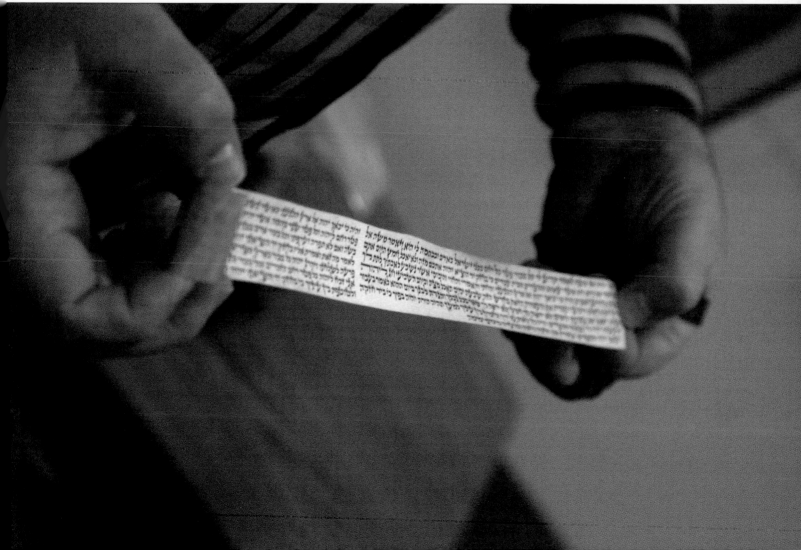

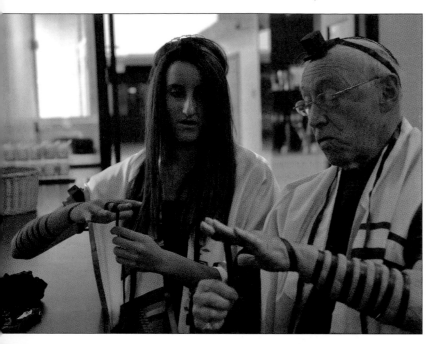
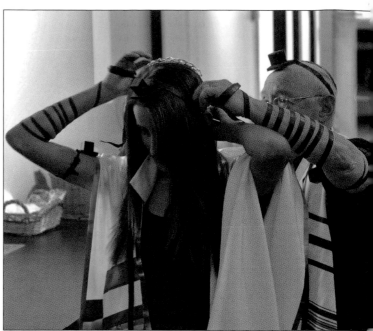
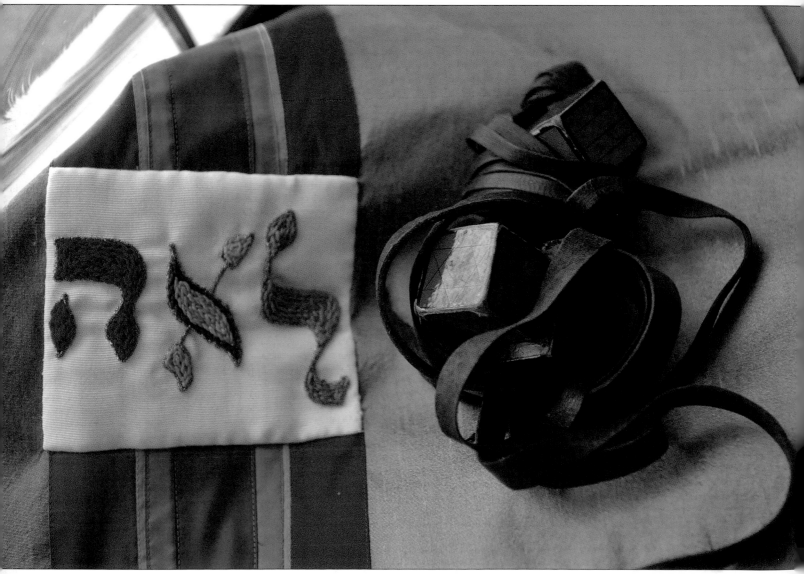

morning service (usually around 7:00AM), so congregants can go to work afterward.

This is also a great opportunity to get candid and detail shots of the child performing the ritual with parents and grandparents included.

The tefillin are kept in a special bag, and sometimes these are custom made with the child's name written in Hebrew. Look at the images on the facing page, and you can see how beautiful this custom is and what a great photo opportunity there is for the photographer to capture. This is one of my favorite components of mitzvah photography that is truly symbolic of the mitzvah.

Among many Conservative and Reform mitzvah families, the tefillin ritual is not considered a requirement, and therefore it does not take place. Be sure to find out if this will be the case with the family you are working with.

Tallit. The tallit is a shawl worn during prayer services once a boy reaches mitzvah age. Among Orthodox Jews, women are not required to wear a tallit. In the Conservative movement, bat mitzvah girls are permitted to wear the garment. Among the Reform Jews, donning the tallit is optional.

Facing page—Though not customary, some bat mitzvah girls will wear tefillin, symbolic of their place in the Jewish community among men. Note the hand-crafted bag with the bat mitzvah girl's name, Leah, embroidered in Hebrew letters. **Right**—Bar mitzvah boy wearing a tallit, a part of becoming a bar mitzvah.

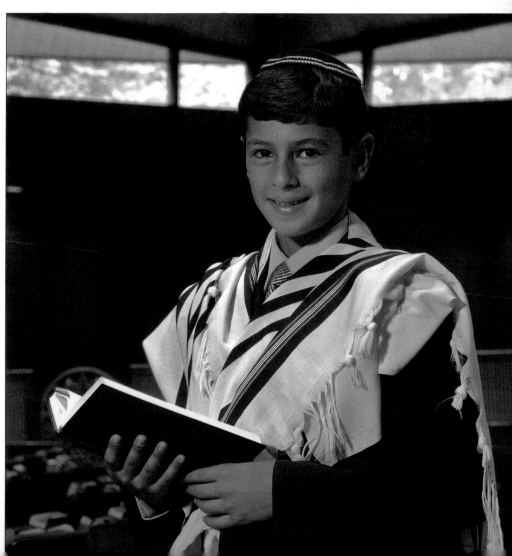

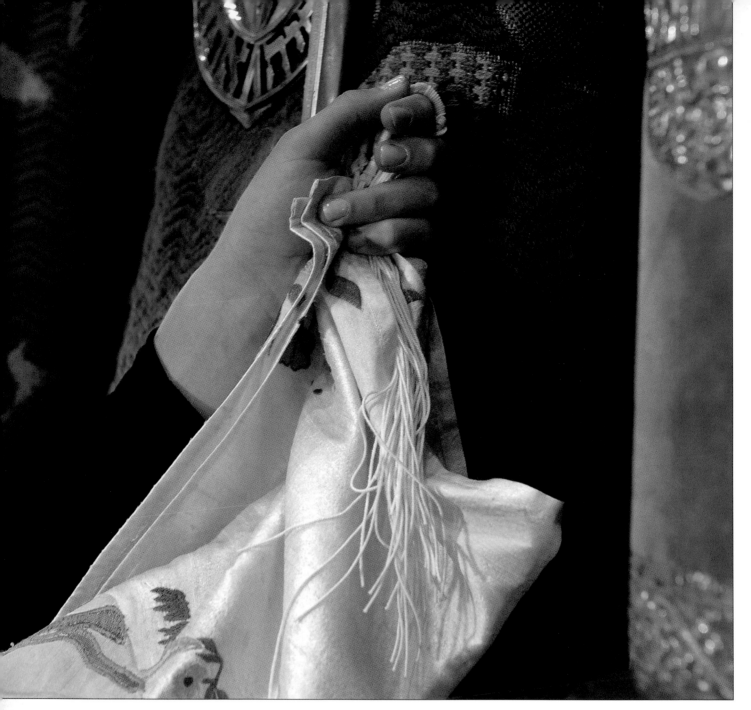

The tallit is one religious article that gets passed down from generation to generation, and just about every Jewish child who has had a bar mitzvah still has his tallit. Some can be very large, which is customary for Orthodox Jews, and others can be very small and dainty for girls to wear. They all must have fringes, called *tzitzit,* at the end, which are symbolic in nature. The knots tied in the tzitzit have a special pattern, which is 7-8-11-13 winds between double knots. The numbers correspond to commandments Jews should follow and are used as a reminder of these religious dictates.

The fringes of the tallit are symbolic and are used to touch the Torah before reading from it.

Since wearing a tallit is required of a male mitzvah child, the item is often purchased for the child by parents or grandparents and is presented to the child during the mitzvah ceremony. This being the case, most families will want photographs showing the tallit being given to the mitzvah child.

The tallit may be stored in a special bag embroidered with a child's name, the Star of David, and the mitzvah date. This is not a religious item (in fact, a simple plastic bag may be used); however, if the bag is personalized, you will want to be sure to get detail shots of this as well.

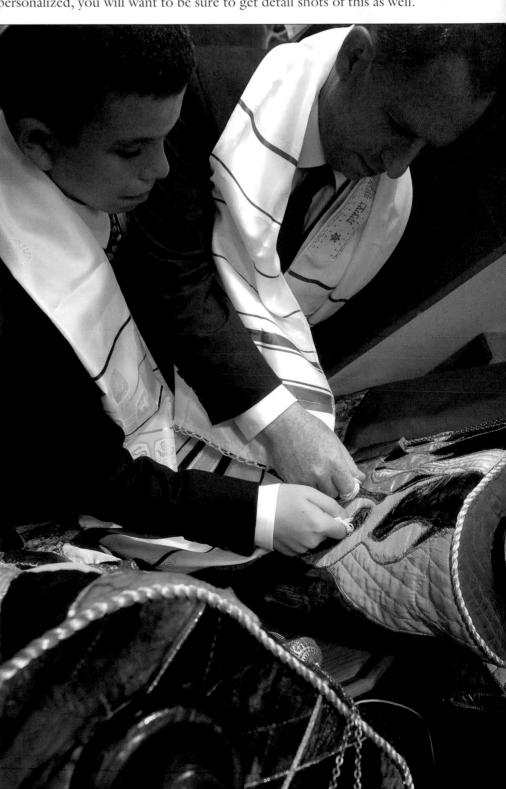

A bar mitzvah boy and dad touching the Torah with the fringes of the tallit.

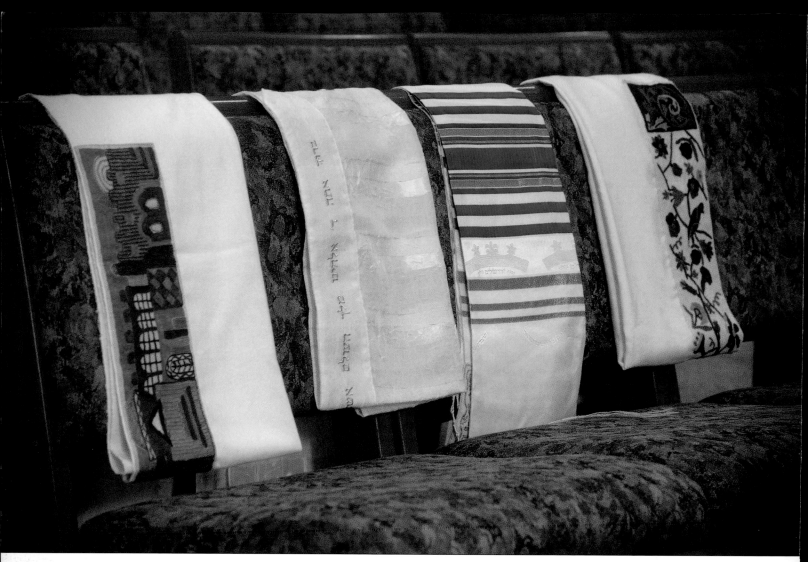

During the course of your mitzvah shoot in the synagogue, you will also want to have fathers and grandfathers wear their tallit when standing with, or reading from, the Torah. Many mothers feel strongly about wearing a tallit, so be ready for this as well.

In using the tallit for pictures with the mitzvah child, I find it is best to fold the tallit in half, so as to make it fit the child better and allow the arms to be exposed. One problem is that a tallit is often so large that it looks like a tent on the child and is not very flattering.

You will want to ensure that the tallit remains equal on each side. With the child moving around, it is easy to have the tallit slide down on one side, making for a sloppy look. Tallit clasps are used to hold the tallit in place. These are sometimes given as gifts by the parents or grandparents, so you will want to add them to your list of images.

Kippah. The kippah, also known as a yarmulke, is a thin, slightly rounded skullcap that is worn by Orthodox Jewish males at all times. Conservative and Reform Jews wear a kippah only during services, and

Above—Tallits come in many sizes and colors. They all have the same religious significance. **Facing page**—A tallit should always be kept straight for pictures. A crooked tallit can be bothersome in pictures later. A special clasp can be used to hold the tallit in place.

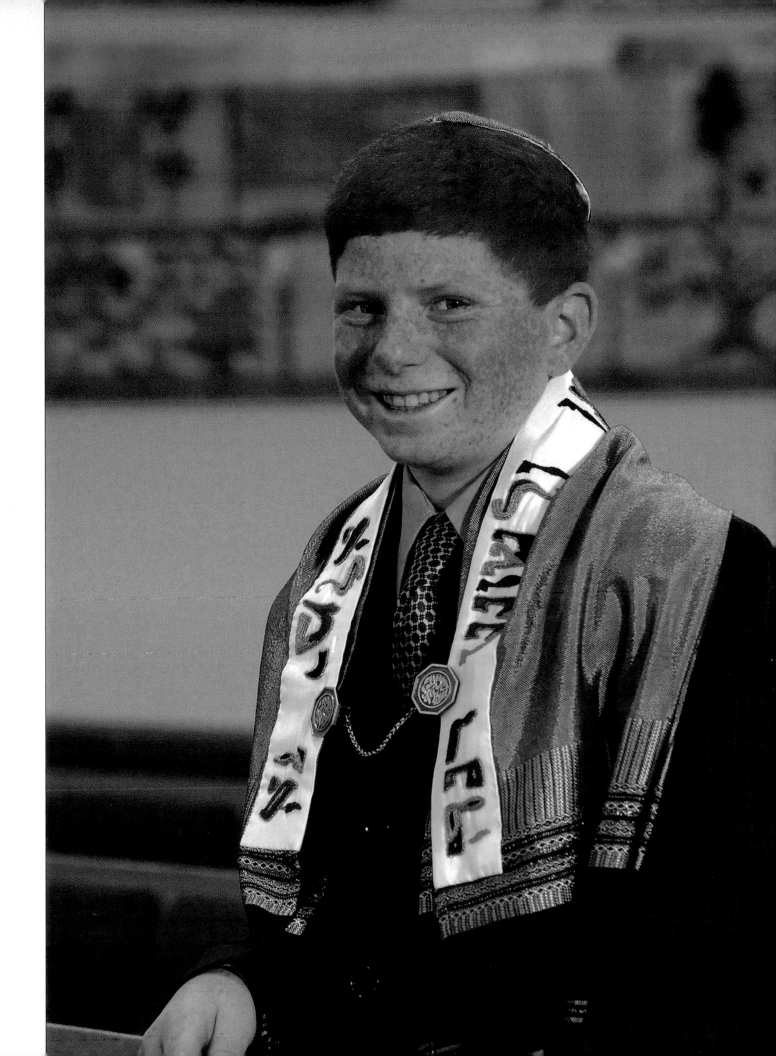

Here, a kippah is given as a gift by the sister of a bar mitzvah boy. Look for these photo opportunities during the course of your shoot with the family.

in the Reform movement it is considered optional. Today, women in the Conservative and Reform synagogues will often wear a head covering of some type when called up to the Torah. Therefore, a version of a kippah is now worn by bat mitzvahs as well.

The kippah is not something we would normally go out of our way to photograph, unless there is something special about the one the child is wearing. For example, if the sister of a bar mitzvah boy has presented him with a special kippah, we have a beautiful photo opportunity.

Many families will order a bunch of *kippot* (plural for kippah) to be given out as guests arrive to the synagogue. These will typically have an inscription of the child's name and date of the mitzvah. It may be worthwhile to have an image of this to be used in some graphic design in an album.

It should be mentioned that when working in a synagogue, you should wear a kippah out of respect for the location and clergy. This is not required of female photographers and should not be done. As you enter the sanctuary, you will find a bin on the side with many kippot

from previous mitzvahs. I myself like to have one of my own, as I am not a big fan of wearing someone else's head covering.

The Ark. Each synagogue will have a wall opening or decorative cupboard in the front of the sanctuary which holds the Torah scrolls. This is called the ark, and while it is not religious unto itself, it is symbolic, as this is where the Torahs are kept. The ark can be very ornamental and have beautiful designs, which work beautifully as backgrounds for album pages.

Look carefully and you will find that there are recessed lights that can be turned on to illuminate the interior of the ark. You will want to do

The ark is where the Torahs are kept. It makes a symbolic background for portraits of the mitzvah child.

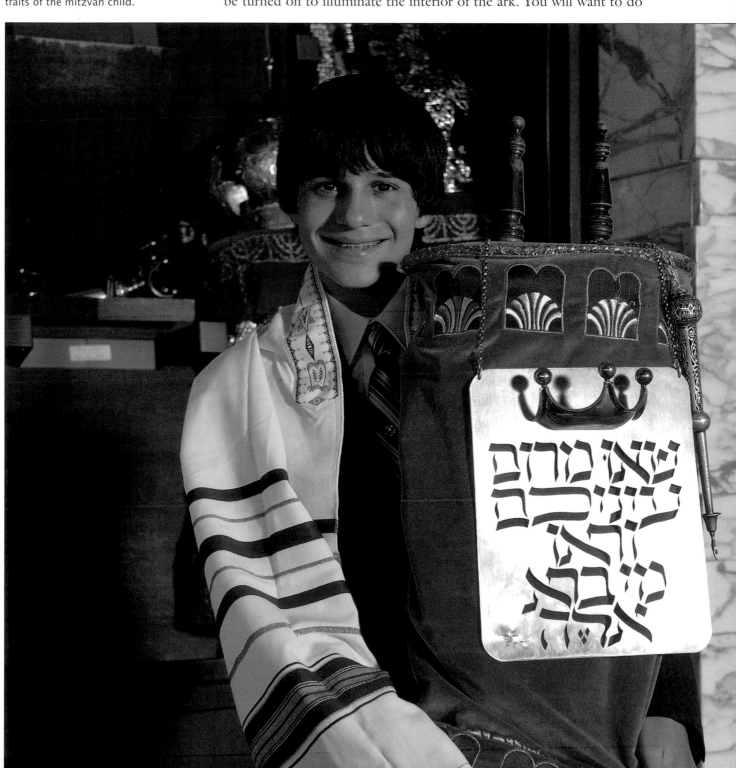

this to have good backlight for your images. With today's cameras, you can shoot without flash altogether for a natural look. Each Torah has a space in the ark and is held by some type of support. Many arks are locked and alarmed, so you need to know this before opening the ark. Many synagogues will have the custodian open the ark for you and remove a Torah to be used.

If you look at the top of the ark, you will see a fixture—the *ner tamid* (eternal light)—hanging overhead. This is representative of the days of Moses when he instructed the Israelites to keep a flame eternally lit near the holy scriptures. (In today's modern synagogue, this may be an electric light, and many times a gas flame is used.) This is a part of the ark structure, and many of my images will be of a family holding a Torah at the ark under the ner tamid.

There are many ways to use the ark in your photos, and there are many examples shown throughout the book.

Sephardic Synagogues. Everything listed so far would be found in a Sephardic synagogue (one of Spanish origins) and is used in basically the same way. The difference here is the Sephardic influence on the

Left—Sephardic synagogues have a unique look that you will want to capture. **Right**—This is a historic synagogue in Washington DC, The 16th and I Synagogue. Notice the grandeur of the ark where the Torah scrolls are kept.

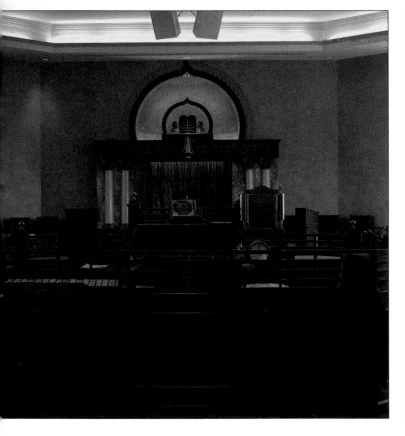

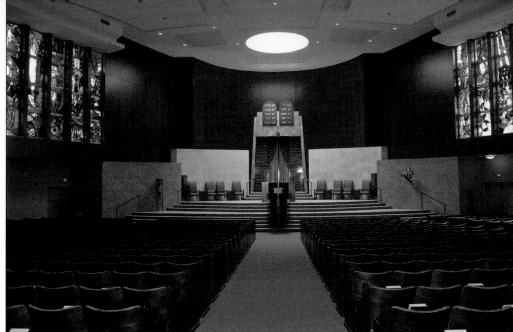

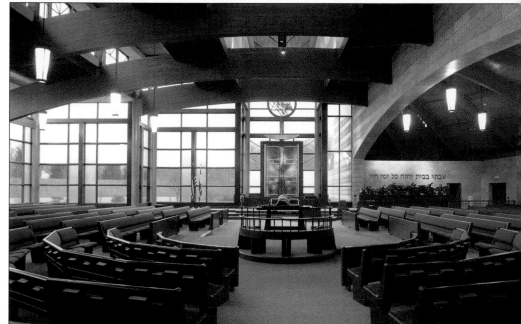

Top left and right—Stained glass is best when backlit. Have a remote strobe and radio set up for this if photos will be taken at night. **Bottom right**—Many synagogues will have plenty of available light to work with. Just watch out for color balance as you will most likely have mixed light sources to deal with.

building design. This includes the ark and bimah from which the Torah is read. You will find various differences in synagogues reflecting the founding members of different eras and nationalities.

Stained Glass and Architectural Designs. As is typical of most places of worship, you will find some stained glass windows somewhere in the facility. Sometimes it may be in a window off to one side or in a small chapel in another wing of the building. Incorporating this into the images can be very dramatic, as well as useful, for designs in the album. One problem that occurs when you are asked to have a shoot in the evening hours is that there is no outside light to backlight the stained

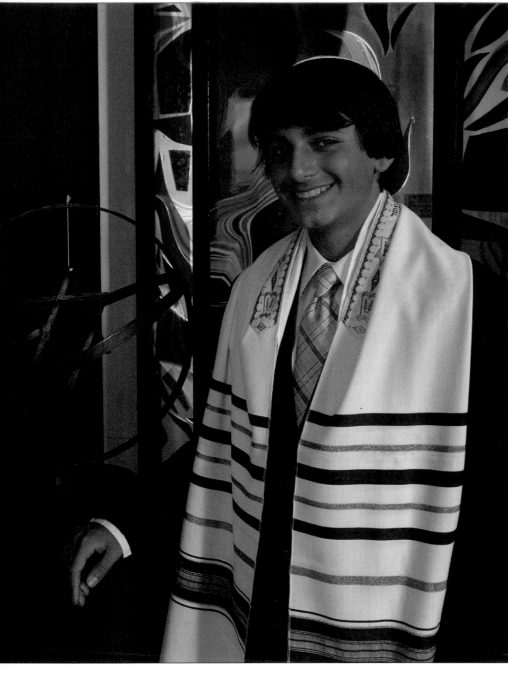

Look at the stained glass behind the bar mitzvah boy. A remote strobe with radio was set up to backlight the glass for the image.

glass. A way around this is to place a portable strobe with a radio outside to light a large amount of the glass from outside. I have done this many times with much success. Even on a rainy day, you can use a clear trash bag to cover your battery-powered strobe to shoot.

4. MITZVAH PORTRAITURE

This chapter is all about photographing the mitzvah family in the synagogue and surroundings. I use the word *surroundings,* since not all images will be taken in the main sanctuary. Today's modern synagogues have beautiful architecture, gardens, and courtyards that are welcome backgrounds for both indoor and outdoor photos. In fact, you should also look for any chapels on the premises, as they will most likely have stained glass you will want to incorporate in your images.

Even during winter months or bad weather, you may very well find an area that has large sliding glass doors that open to the outside. You can then incorporate the outdoors in your images, with the family standing, dry and warm, just inside the doorway. I have done this several times when a family wants fall colors in the pictures but it is a cold and/or rainy day outside.

SCHEDULING

When scheduling the synagogue portraits with the family, be sure to ask if they will be doing video that day and if it is scheduled before you. This is critical information, as you will be photographing children who

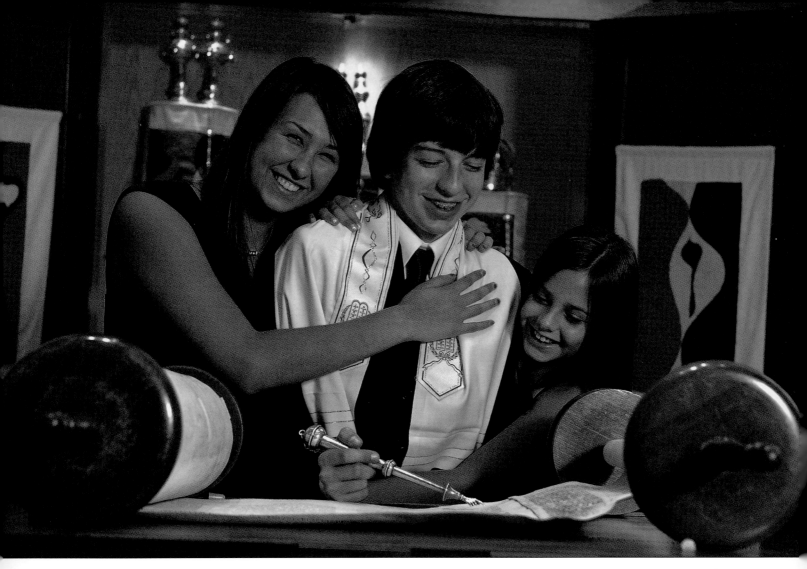

will tire quickly. You do not want to follow a one- to two-hour video session expecting the children to be agreeable.

You will also find that many mothers will try to schedule way too much for the day, including school, work, hair, makeup, and a rehearsal with the rabbi, all followed by pictures at 7:00 or 8:00PM. There is no way you can get an entire family that is tired, hungry, and out of it to look good in pictures. Coach the mom as to what is best for the family. I tend to prefer a morning session, having the family ready for me around 10:00AM. They can always do a rehearsal and video after my shoot.

ORGANIZATIONAL TIPS

When planning your portrait shoot with the mitzvah family, it is important to break the shoot down into groups. This will keep you organized and ensure a good workflow. The main focus, of course, is the

When working with children, it is often best to let them have a good laugh and relax a bit. Many times I will tell them to stick their tongues out at each other to get them to start laughing and become relaxed.

mitzvah child, and this will be your starting point. Thereafter, you will be working with parents, siblings, grandparents, and, on occasion, a favorite aunt or uncle. You will want to limit the number of people that show up for pictures, as this can get way out of hand. I had one family show up with an entire extended family without warning, including aunts, uncles, and their children—all together there were over twenty-five people there! All were dressed for pictures because they were told by the mother that this was their chance to get holiday pictures at no charge.

What a mess this was. How do you tell everyone that the mother just took advantage of you? Today, I always review who will be at the photo shoot and remind the parents that it is for immediate family only, ten to twelve at the most. Assume that there will be a mitzvah family of five or six, plus four grandparents for a total of ten or so.

Planning for photos works best as follows:

- Mitzvah child alone
- Mitzvah child and parents (together and individually)
- Mitzvah child and siblings (together and individually)
- Mitzvah child and siblings with one parent at a time
- Mitzvah family (parents/siblings)
- Mitzvah family with maternal and paternal grandparents
- Mitzvah family with maternal grandparents only
- Mitzvah family with paternal grandparents only
- Mitzvah child and siblings with maternal grandparents
- Mitzvah child and siblings with paternal grandparents
- Mitzvah child only with maternal grandparents
- Mitzvah child only with paternal grandparents
- Siblings (individual portraits of each)
- Parents by themselves
- Maternal grandparents
- Paternal grandparents
- Generational photo of the men if bar mitzvah
- Generational photo of the women if bat mitzvah
- Mitzvah child and clergy if they ask for this
- Mitzvah child and aunt or uncle (optional)

YOU WILL WANT TO LIMIT THE NUMBER OF PEOPLE THAT SHOW UP FOR PICTURES, AS THIS CAN GET WAY OUT OF HAND.

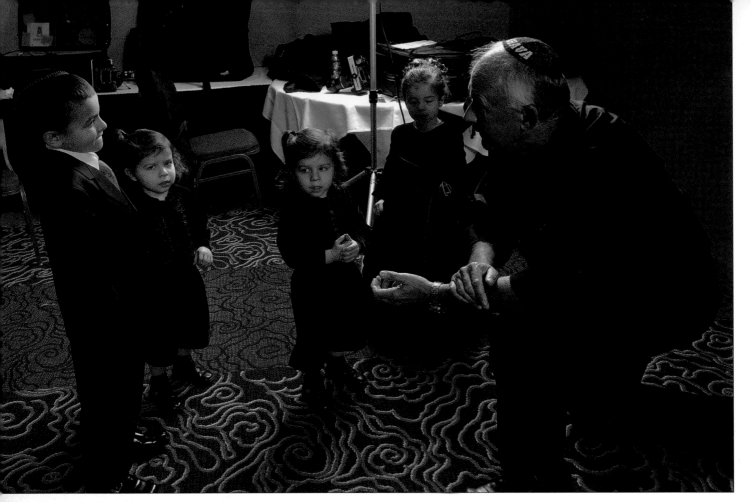

For each grouping, you should plan on two styles of portraiture—religious and secular. The religious photos will be taken within the sanctuary using the Torah and other religious articles. Secular photos may be taken outside of the synagogue or in a hallway or vestibule. A backdrop may be used in this case; I prefer to use a background canvas only if the family requests it.

So, with two styles of pictures, you are looking at forty or so setups for pictures—with children and the elderly, who may be using walkers! You should be able to capture all of the images in less than two hours. If you take any longer, people may tire, and you will lose your subjects. Also, keep in mind that grandparents may have come from out of town and have not seen the family for some time, so lots of hugs and kisses and stories are to be expected.

When working with the family, your people skills are crucial for having a successful shoot. You should always be in control but never look or act pushy or stressed. An easygoing smile and a relaxed attitude are mandatory. If you upset a grandmother, that will be it for you, as word about your demeanor will travel quickly. When working with young chil-

Here I am, talking to the children before photographing them. Notice how I am at their level and making eye contact.

dren, take your time and talk to them before starting with the pictures. This will help them to see that you are not a threat.

The next few sections of this chapter will show you the type of images that the mitzvah family will expect from you. These are typical poses that are common in mitzvah photography. Some of these are must-haves, and as I go through the set of images, I will point out which photos are the most important for the family.

Note that tradition will dictate some of the poses and the subject groupings. For example, the act of the father passing the Torah to the bar mitzvah boy is very emotional and representative of the mitzvah custom of passing the laws of Judaism down to the son. This is an important moment to capture for the family.

This image of a father passing the Torah to his son is representative of passing the Jewish laws and traditions from father to son. This is a must-have image for any mitzvah family.

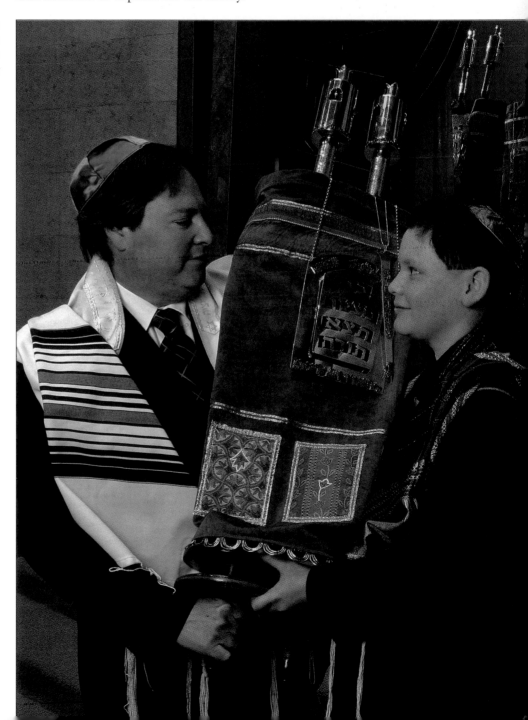

Left—The use of indirect light can help to create a soft, tranquil feel in the image. **Right**—Here I used a 200mm zoom lens to show the parents in the background. The picture is taken outside under the façade of a synagogue chapel. Notice how the indirect light and geometry of the structure add to the image. **Facing page**—Reading from a prayer book is a classic mitzvah pose.

PHOTOGRAPHING THE MITZVAH CHILD

As soon as the family arrives for their appointment, you will want to start photographing the mitzvah child, getting images of him or her wearing a tallit and reading from a prayer book. There are many ways to pose this image, and a lot is dependent on the child you are working with. Girls are very good at posing, and boys are usually less comfortable. Window light, or indirect light, is great for these images.

Another way you can make use of this pose is to capture the parents in the background. Though there are a variety of ways this can be done, the best option is to use a long zoom lens. Keeping the child *and* parents in focus makes the image even better.

It will also be important to get a set of images of the child holding the Torah. The key is to have the child look comfortable, which can be

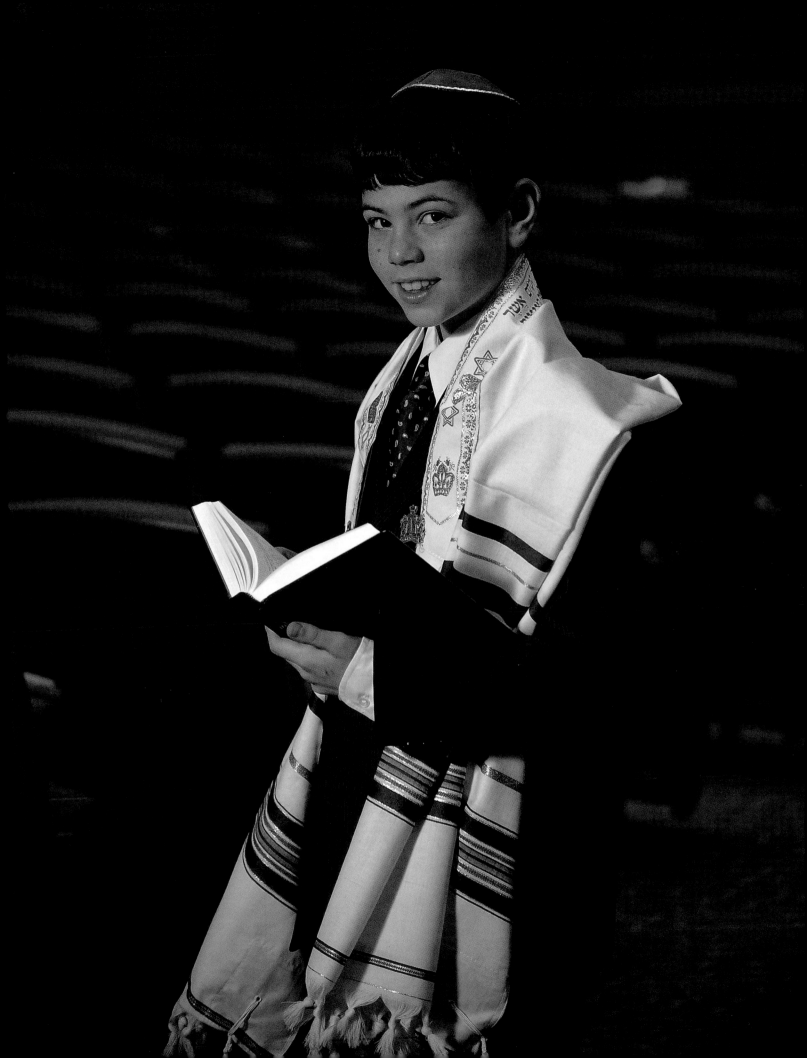

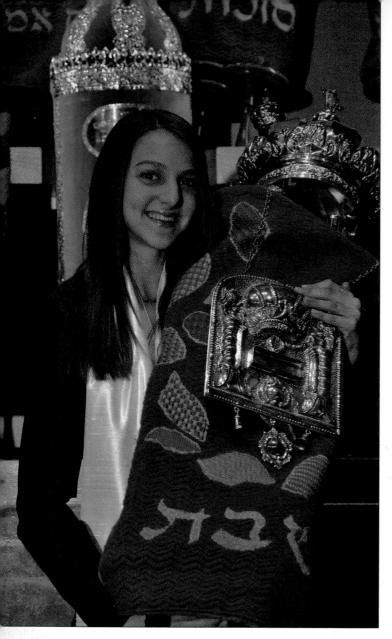

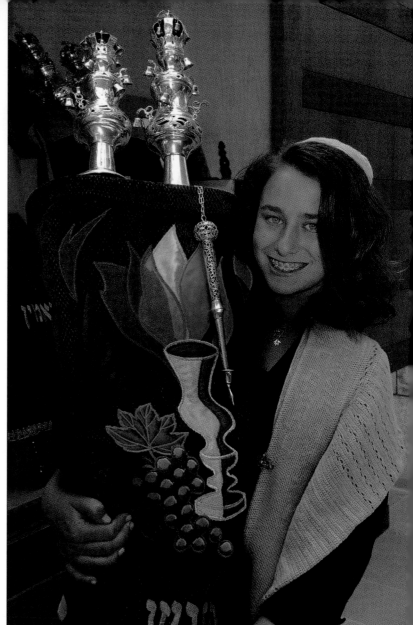

Every family will want a photo of their mitzvah child holding the Torah.

difficult considering the weight of the Torah (typically thirty pounds or more). Many times, I will have the father help hold the weight by having him put a shoulder behind the Torah and shoot tight to exclude him from the image.

When capturing these images, watch out for reflections from the metal breastplate on the Torah. Indirect flash works best here.

If this is a bar mitzvah, be sure to capture a photo of the father passing the Torah to his son. To help emphasize what is taking place, be sure to allow a little separation between the father and son and have the boy's hands outstretched. The trick is to have the boy look up at his father without laughing. A way you can do this is to have the boy look just over the dad's head at an object on the ceiling.

You will want to shoot this pose from several different angles, so walk around and change your perspective. By shooting from a low angle, you add to the feeling of the boy looking up to his father. A good second pose is to have them turn to you and face you directly while holding the Torah together.

Plan to get photographs of the child reading from the Torah, as the family will expect an image of this occasion for their album. When taking these pictures, it is important to pay attention to your background. Sometimes I will move the Israeli flag into the background to add meaning to the image. Other times, I will make sure to show the open ark in the background.

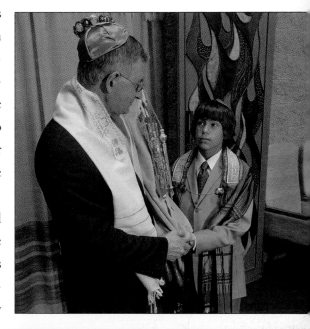

Here again, shooting from all different angles adds interest in the images. Shooting over the child's shoulder is also a great angle, giving the viewer the feeling that they

Be sure to change up the angle of your photographs to get a variety of images of this important pose.

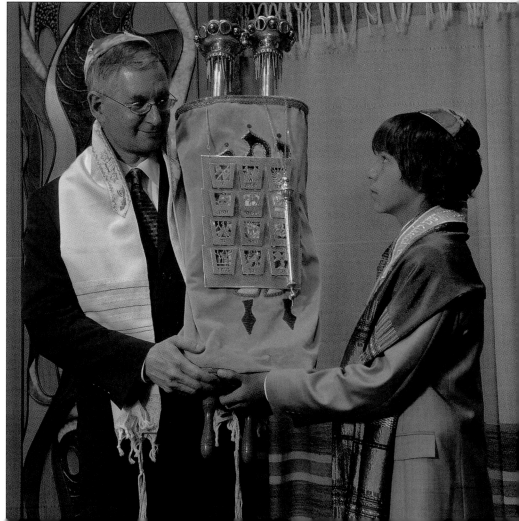

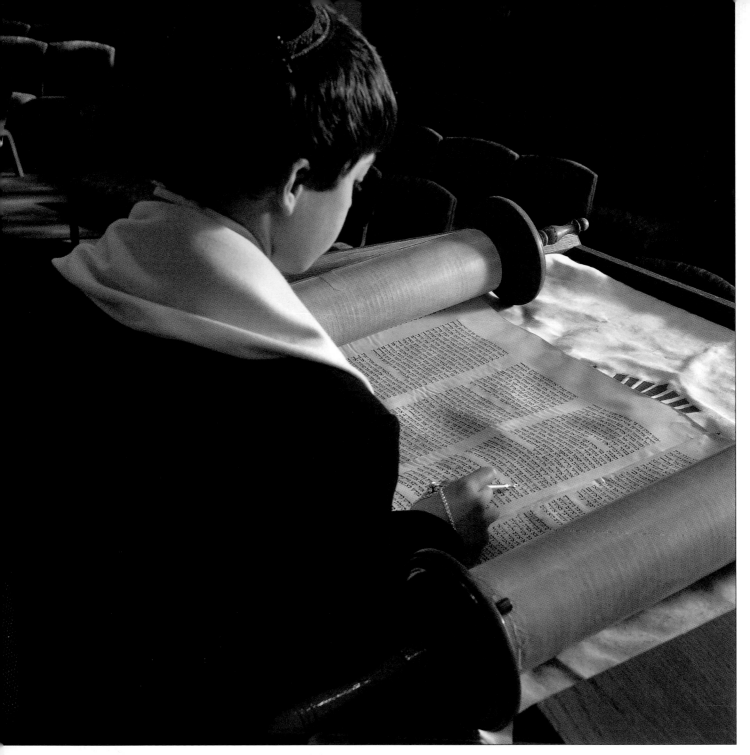

are reading along with the child. With the Torah open for reading, there are many variations that can be added, such as only a sibling in the picture looking up at the older brother or sister.

With the ability to use remote flash with a radio transmitter, your creativity is unlimited. Hiding a flash strobe in the ark can provide a single light source with dramatic results. I have put strobes behind stained glass panels, openings in vestibules, behind a menorah—you name it. I find

Above and facing page—Use of indirect light or reflected light adds a nice feel to the images. Strive to capture these images from different angles for added interest.

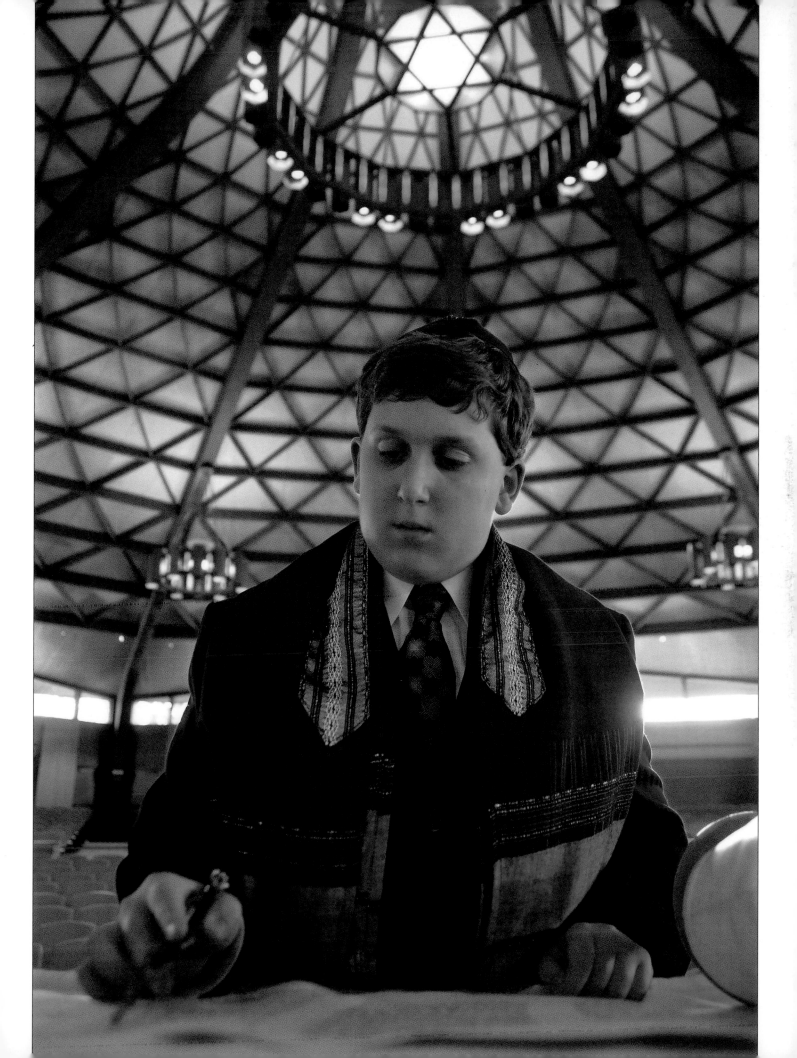

Top—This is a dramatic photo of the Torah as it is being lifted by the father of the bar mitzvah boy with the older brother next to him. This should not be attempted, as there is a risk of damaging the Torah. In this case, I was working with the three of them and just caught the moment when the father decided on his own to lift the Torah. **Bottom**—A younger sibling looking up at the mitzvah child is priceless. Timing is everything when capturing a natural look, so have both of the children looking down at the Torah, then ask the younger child to look up. Be ready to capture the shot.

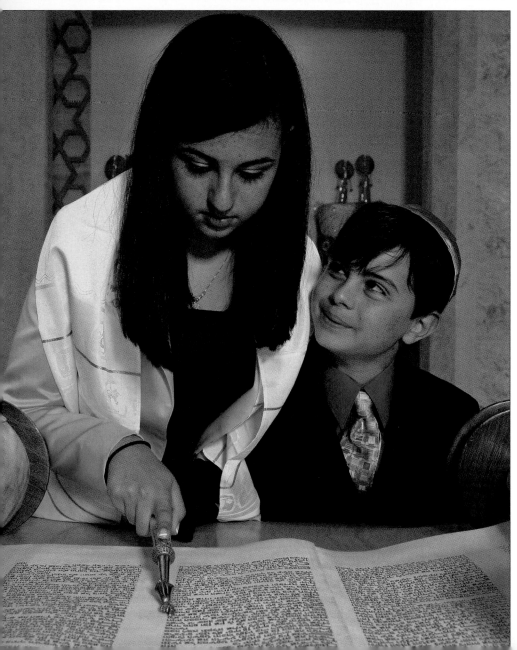

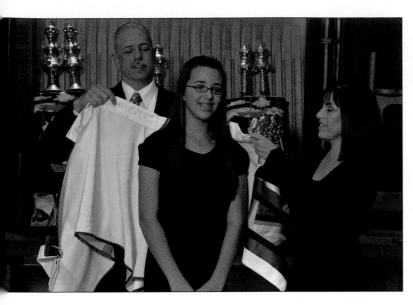

Another must-have image shows the parents presenting the child with a tallit. Don't be afraid to ask the parents to give the child a kiss; you may be rewarded with a priceless image.

that PocketWizards work best, as they do not require a line of sight that an IR type of command signal requires.

THE MITZVAH CHILD AND PARENTS

There are many images you will want to create incorporating the parents with the mitzvah child. Just about any pose can include parents. Don't be afraid to separate them and have individual images of each parent with the children doing or re-creating some rituals that would be part of the service. Today, Conservative and Reform families are okay with women participating in a service, so having a mother reading from the Torah is quite acceptable; this is not the case, however, when working with an Orthodox family. Also keep in mind that many families today are interfaith, and the mother may be the only Jewish parent. She may therefore want to have more of a role in the pictures taken with her and her child.

One of the must-have images is where the parents (or grandparents) present the child with a tallit. You will want to capture this or re-create this moment in your photographs. There are a few things you need to consider when setting up this pose: The mother should be in the forefront, with the father slightly behind. The tallit should be placed over the parents' hands in a way that shows the blessing embroidered on the tallit. The child should be off to the side a bit, so as to give the feeling of

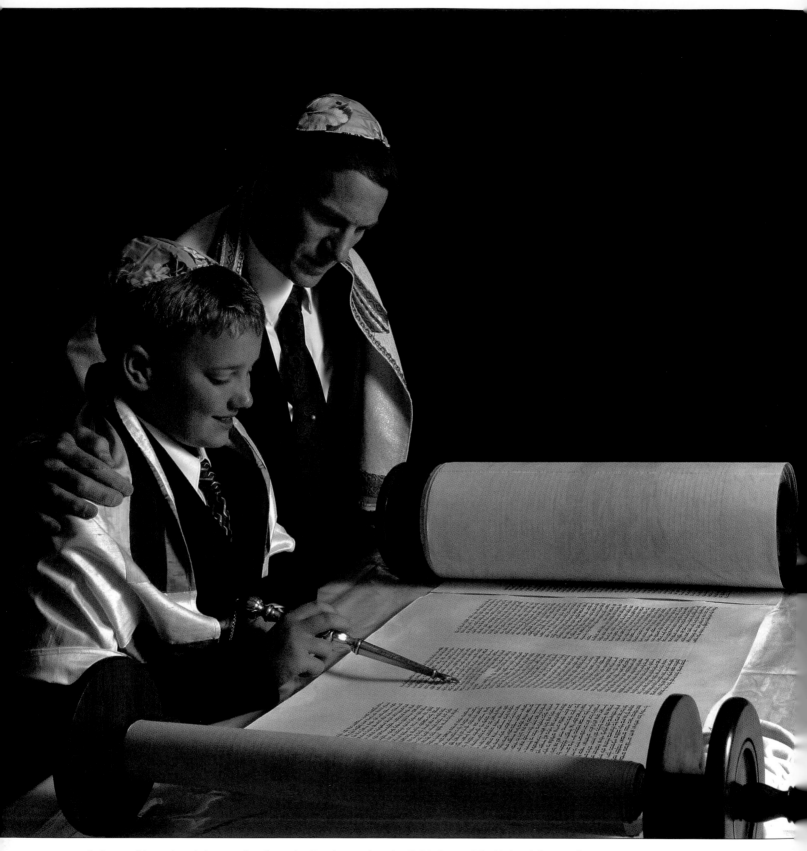

Father and bar mitzvah boy reading from the Torah together. I call this image *The Light of the Torah*.

the presentation. Once you have your composition and take the photo, let them go through the motions of placing the tallit on the child. After they have done so, let them hug and kiss the child. Many times you will be rewarded with a great facial expression on the mitzvah child, which will make for a great photograph.

One of my favorite images is with a father and bar mitzvah boy reading the Torah together (a mother and daughter works just as well), with the father looking like he is coaching his son in the reading of the Torah. What makes the image on the facing page great is the dark background and the light that seems to be coming from the Torah scroll shining on their faces.

Getting the image is simple. Set your camera to a low ISO—100 if you can. Select a shutter speed of $\frac{1}{200}$ to $\frac{1}{250}$ second and an aperture of f/18 to f/22. Have a family member hold your remote strobe (with radio transmitter) facing down toward the Torah scroll. The white parchment will act as a reflector and will give you just enough light to expose the faces. Adjust both the light source intensity and the aperture to get the final effect you want.

Be sure to capture a photo of the parents with child holding the Torah.

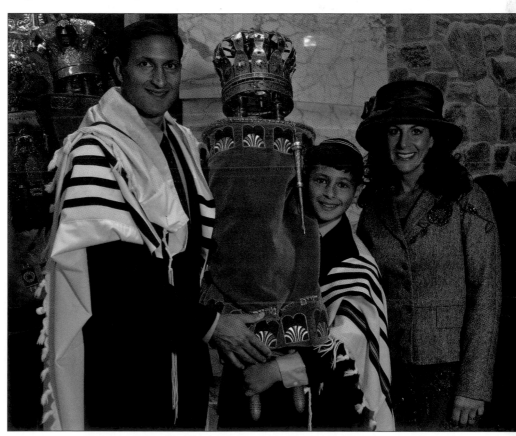

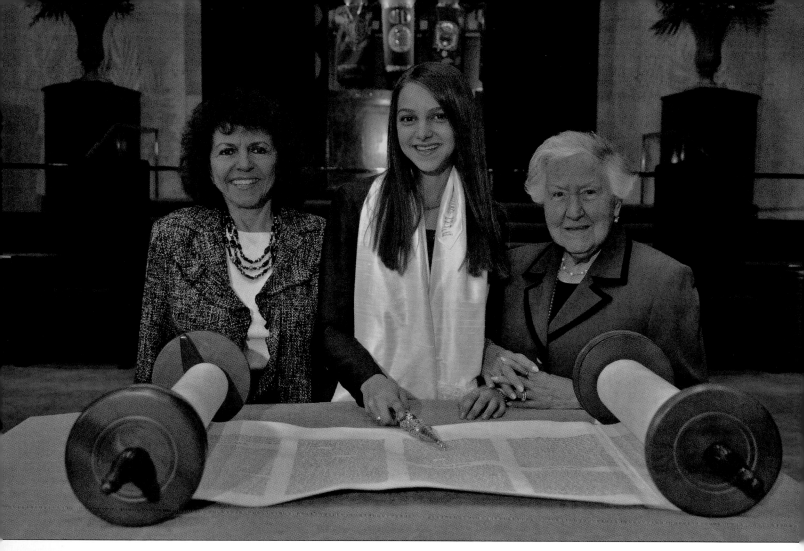

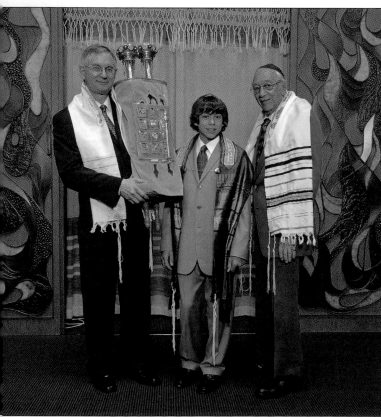

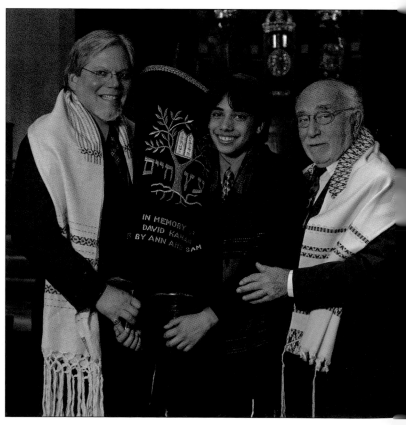

Facing page—Generational photos are a must for any mitzvah family. Don't forget to take photos of both the paternal and maternal sides of the family.

Of course, it goes without saying that a picture of the mitzvah child holding a Torah with a parent on each side is classic. When doing this, I try to have only the mitzvah child wear a tallit, as I want them to stand out as being the mitzvah child. Some fathers may want to wear a tallit while holding the Torah, so you may have to give in.

THE MITZVAH CHILD AND GRANDPARENTS

Grandparents are important in the planning of the mitzvah and the mizvah photography for several reasons:

- They are young enough to be part of the planning and decision-making process. The child is only twelve or thirteen, the parents are likely in their mid-thirties, so the grandparents are most likely in their early sixties. They often contribute to the budget.
- The grandparents likely have more traditional ties to the religion and will want to have photos that are truly representative of a mitzvah.
- The grandparents will spend the most money on reprints and are an important customer to you.
- These elders will have much to say about you as a person, and what they say will have a great deal of influence on your public perception and your reputation as a photographer.

The poses taken with parents can be taken with grandparents just as well. One of the key images you must have is a generational photo—three or four generations of men or women.

THE MITZVAH CHILD AND SIBLINGS

Your future bookings with the mitzvah family can be influenced by the pictures you take of siblings with the mitzvah child. You are going to want to include them in the pictures, and this is not always an easy task. The younger siblings may be feeling some jealousy about all of the attention going to the mitzvah child, and older siblings may feel out of it since they have had their mitzvah. Whatever the case, you will want to include them, so here are a few ideas to get you stared.

Younger siblings are easier to photograph, and there are several classic poses. One of my favorites is having a younger child look in a prayer book with the mitzvah child.

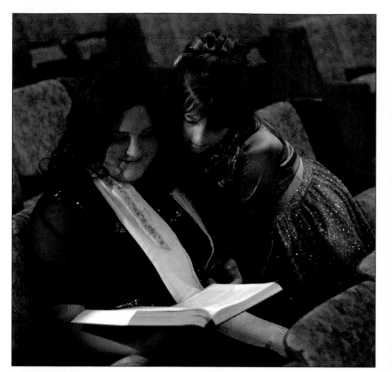

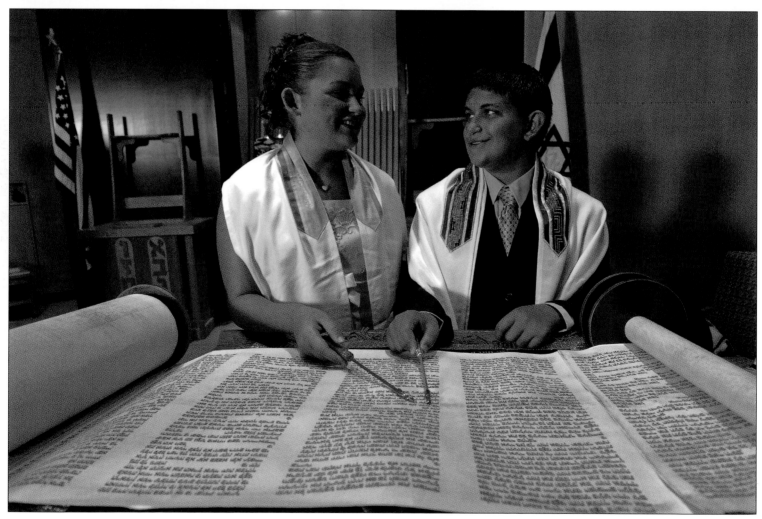

Top left—Including siblings in pictures is a must when photographing mitzvahs. This also helps in future booking with the family down the road. **Top right**—Having older siblings participate in some action will help get them involved in the pictures. Here the teenagers are helping to dress the Torah after the reading, preparing it to be put away. **Bottom**—Photographing twins presents unique challenges. Try to find the differences in their personalities and capture them in a meaningful way.

It can take a little extra effort to get some good shots of the mitzvah child with their older siblings. Sometimes having them perform some action or just kidding around will give you some good results. If all else fails, include them in the family group photos.

Twins. Photographing a mitzvah for twins presents unique challenges. You will want to have the children in many pictures together, but at the same time, you will need to find the differences in their personalities and capture their unique qualities in a meaningful way. I always like to have different but complementary pictures of them that can be placed side by side in an album. This works especially well when one child is a boy and the other is a girl. Most parents will have two albums made, so each child can have their own mitzvah album when they grow up and start their own family.

ADDRESSING SPECIAL NEEDS

Some families have special needs—elderly grandparents, physical disabilities, children with autism, etc. As the photographer, you should ask about any circumstances that may affect the photo session. Note that if you will be working with a family with special needs, you will also want

Extra time and creativity are needed when working with families that have special needs. Plan on this, and look for ways to work around any handicaps. Here, the grandfather is included by having the Torah brought to him.

to schedule some extra time for the session. Many times, I will give everyone a fifteen-minute break during the shoot. You will need to be extra patient and use your creativity to come up with image options that will work.

When photographing children with autism, I find that working without flash is best. Even indirect bounce flash seems to bother some children. I also limit the number of poses. In my opinion, getting a few really good pictures is better than photographing a lot of poses that show the child stressed out.

Speaking of stressed-out kids, I run into a lot of mothers who are neurotic about grooming their children for pictures. Every two minutes, they stop the shoot to fix the hair on a girl or straighten the tie on the mitzvah boy. The best way to handle this is to have the parents go outside for some of the pictures. This allows you to work with the child uninterrupted and even takes some of the stress off the child.

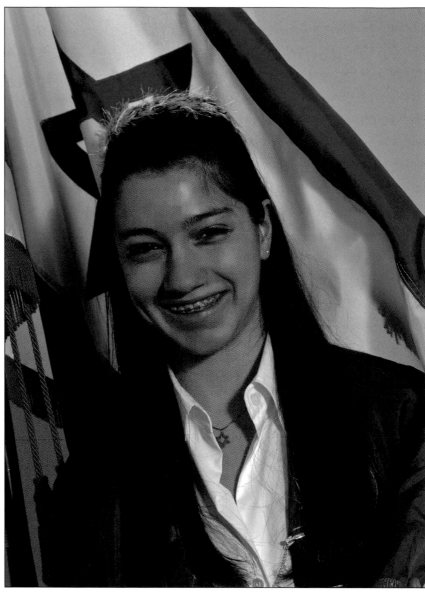

Above and facing page—Showing a mitzvah child a retouched image during the shoot can help with their comfort level if they are concerned about braces or acne.

At this age, many children will have braces on their teeth, and this may well affect their comfort level while they are in front of your camera. I carry a set of retouched images in my camera bag showing a mitzvah girl with braces and an identical picture with the braces removed. I use this to show that there are ways to get rid of them. I let the family make the final decision as to what they will do, which helps the child feel at ease. The same goes for severe skin problems.

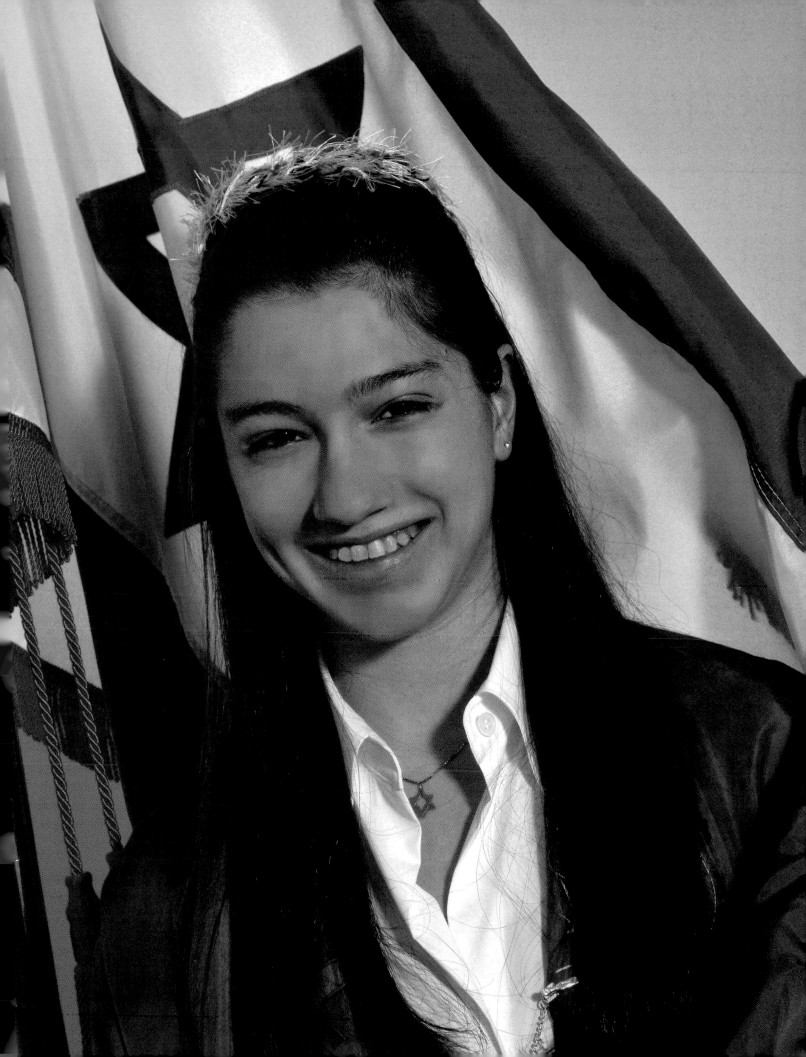

5. THE PARTY

Mitzvah parties are very different from wedding parties. There are several rituals and customs that take place, as well as many must-have images you need to be prepared for. Most parties run about four hours and have a timeline that the DJ or caterer

will be working off of. You will want to review this with them to get yourself ready for the day's events.

In the following pages, I will present the timeline I work from. Having the timeline planned out in advance helps keep me organized.

BEFORE THE PARTY STARTS

Arrive one hour before the party starts (a 7:00PM party is common, so in this case, plan to arrive at 6:00PM). Get pictures of the room, table decorations, party favors, sign-in boards, sign-in books, cocktail napkins, chair decorations, and everything that the family has chosen especially for the event. Much time and money goes into developing the "theme" for the mitzvah, and the family will want images to document their selections.

Now is also a good time to get a picture of the cake, if the family has opted to have one. You will probably get a picture of it later as well, but

Be sure to capture details of decorations and meaningful gestures. In this case, the family's decorations were a charitable contribution to Jewish services.

 ARE YOU WONDERING ABOUT MY BAT MITZVAH THEME?

The theme of my Bat Mitzvah party is "Mitzvot" or Commandments. It is important to me to help people and to keep our earth healthy. The words you see on my centerpieces are transliterations of some of the commandments that are important to me: My volunteering activities have included the mitzvot: Gemilut Hasadim which is defined as "acts of loving kindness;" Tikkun Olam or "repairing the world." and Bal Tashchit meaning "do not waste or destroy."

Gemilut Hasadim - I have been fortunate to work with children and families who have lived at the Hackerman-Patz House. This center provides housing for those who are undergoing limb-lengthening procedures at Sinai Hospital for extended periods of time.

Tikkum Olam - I have been working help to save the people of Darfur. By creating and selling pins made from safety pins and beads, I was able to earn over $1,000 to contribute to the Save Darfur Coalition. www.savedarfur.com

Bal Tashchit - I have volunteered to work the land at our local Jewish Community Center to grow organic food. The vegetables are sold at our CSA, Community Supported Agriculture.

Be sure to get photographs that capture the unique theme of the mitzvah celebration. Detail shots like these make a great addition to the mitzvah album.

experience has taught me that it is good insurance to get a photo as soon as possible. I have had cakes fall or become completely wrecked before photos were ever taken. Nowadays I photograph early as a precaution.

I will have asked the family to arrive early for pictures with the out-of-town guests and relatives. They are usually late, so I tell them to show up an hour beforehand, and they typically arrive twenty to thirty minutes before the party starts. I will have a series of family shots and will

Top—I try to get a photo of the cake early on in the celebration to ensure the best shots. Time and tiny fingers can wreak havoc on the cake as the party wears on. **Bottom**—An image like this can be a great opening page shot for the reception portion of the album.

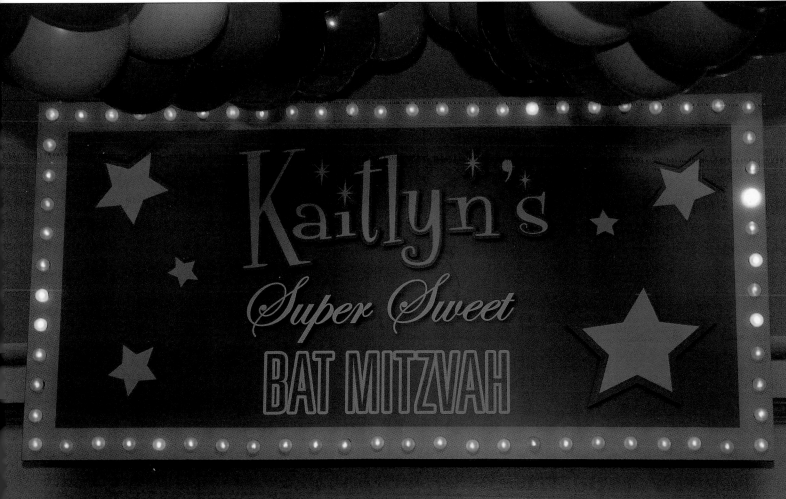

Get your opening and closing shots for the album right at the beginning of the party, when everyone looks their best. This way, you can be sure you've got this covered.

Kids' games are a part of every mitzvah, and using slow shutter speeds help capture the motion.

typically get my closing picture now. At the end of the party, I don't want to wait for them to have said all of their goodbyes, and they usually look less polished at the end of the night.

The images on the facing page are good examples of closing shots I try to get, depending on the family and the mitzvah child.

PARTY TIME

Now the party is officially ready to start. Two things will happen at this time: the cocktails for the adults and most likely games with the DJ for the kids. Cocktails will last for about an hour, and though I don't really

like taking pictures of people with food and drinks in their hands, it is still expected by the family, so it's best to deal with it and get some group shots of guests and relatives.

You will also need to get back to the kids' games (commonly Coke and Pepsi, Lox Bagel and Cream Cheese, Levitating Chairs, etc.). These make for fun shoots, and dragging the shutter to use motion in the images results in some interesting shots.

INTRODUCTIONS

At the end of the cocktail hour, the DJ and his dancers will have the guests enter the main room and get ready for the introductions. The siblings come into the room and are introduced first, followed by the

Facing page—Be sure to know which doorway the family and mitzvah child will be coming through, as well as the direction of any supplemental flash strobes you have on the floor. **Below**—Parents can be very emotional when welcoming guests and talking to the mitzvah child. These moments make great photo opportunities, so be sure to be ready to capture the moment.

The blessings over the bread and wine are done prior to the meal. Grandparents are usually honored with this tradition.

parents and then the mitzvah child. All of this happens quickly, so you will want to be sure to know which doorway they will be coming through. I have seen some very dramatic entrances, and you will want to be ready for this.

The parents will most likely have a few words to say immediately after the introductions are made. Their speeches can be very emotional, and there are many great pictures that can come out of this. You will also want to be sure to get the crowd assembled for a big group picture, or at least get a shot that shows the number of guests in attendance.

KIDDUSH AND MOTZI

Following the introductions, the grandparents (or other special relatives) say the blessings over the wine and bread. The caterer will bring a table to the center of the dance floor with wine and bread on a tray. You, of course, can have them put it where it is best for both background and light.

Be sure to have the mitzvah child stand alongside the persons making the blessings, as this is a photo opportunity that is very often overlooked. The blessing over the wine *(kiddush)* is recited first, followed by the blessing over the bread *(motzi)*.

In some cases, the grandparent is not able to make it to the dance floor and will make the blessing while seated at the table. Be prepared to capture the photo at the table if you know or feel that this will be the case.

TABLE SHOTS

Mitzvah families will want table shots. Selecting a wide angle lens will make the job easier.

At about this time, the first course or salad is served to the adults. The kids may play games or may have their meal at the same time. This is the time to get those table shots we all love so much. Though this is not a task that many photographers enjoy, it is important to the families. I have had many families thank me for getting these quick group shots. Conversely, if there are people missing from a table and I can't get the shot, I never hear the end of it.

My goal in getting the table shots is to capture the best image I can, quickly and with minimal

interference. I know that guests really don't want to get up from the table and leave the meal they just started, so I use a very wide angle lens and have everyone look up as I shoot from overhead. In less than five seconds, I will have taken two images and, in the end, everyone is happy.

By the way, this is a time when all of the guests (many future mitzvah families) will be seeing you up close and in action. They will notice how you work with them while you are capturing the table shots. Your attitude is important, and being seen as someone who is always smiling, helpful, and respectful of the elderly is the only way to go. Many families have called me up to book me after they have seen me at a recent mitzvah. They will make a comment like "You were so nice to us during the pictures at the table, and we really like your style. Can we book you?"

Note: There is another take on table shots that I always make a point to capture. During the course of the party, I will photograph couples

Be sure to know beforehand if any special entertainment or presentations will be held. You want to be sure you are well prepared to capture a special dance troupe or a sport mascot if one appears.

dancing. Since there are usually couples that do not dance and stay seated at the table, I also make my rounds during some of the dance sets to make sure I get photos of the seated guests and relatives.

THE HORA

Every mitzvah—and every Jewish wedding, for that matter—will have the hora, a circle dance. This Jewish tradition, which is also common among many ethnic groups (Greek, Turkish, Romanian), can last up to ten minutes. During the dance, the mitzvah child, siblings, and parents will be raised up in a chair and danced around. Of all of the pictures you will take of the party celebration, these have to be the most important.

Top—This image of a grandmother blowing a kiss is priceless. **Bottom**—During the dancing, be sure to get the couples that are seated at tables, as they may never make it into any other pictures.

Before the hora begins, you will want to make sure you have sufficient space on your memory card (or enough film in your camera), and that your batteries are okay. You will also want to ensure that you have a backup camera at the ready, should the need arise. There is no way you can miss these pictures. There have been cases where a camera has failed right in the middle of the dance, and I just ran to my bag to pick up a backup that was all ready to go.

Left and facing page—Of all of the images taken at the mitzvah party, the chair-lift during the hora will be the most important. Be sure you know when the hora will take place so you are ready.

I use a wide-angle lens for this (about 17–24mm) so I can get all of the action while staying in tight. Be sure to look at family members who are dancing in the circle, as many times you will get great photos of parents and grandparents cheering on as a child is lifted in the chair.

The pictures of the chair lift are used many times in the centerfold of a magazine-style album and are always a key image for an album. Whatever you have to do, be sure you are there for the hora and the accompanying chair lift, period.

THE CANDLE LIGHTING

The candle lighting is another mitzvah tradition that families will want excellent photographs of. Sometimes there will be a candleholder with twelve or thirteen candles. Other times, there may be a cake. During this time, the child will read a few words about a person before honoring them with a candle to light. Your job will be to get the picture of the honoree lighting the candle. You will also need to get a nice posed picture of the chosen person with the child.

A mistake many photographers make is not paying attention to the background of the pictures during the candle lighting. Many times you will find that the DJ's head appears in all of the images, as he or she is

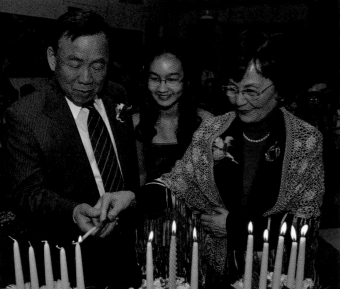

right there in the background. Be sure to take care to eliminate background distractions, when possible, before getting these important shots.

Candle lighting is a tradition at many mitzvahs, and these photographs will be sure to make it into the album.

Another point to keep in mind during the candle lighting is that you will be there in the middle of the dance floor, where everyone will see you while are working at taking the pictures. I make it a point to stand off to the side until I can jump in, get the shot, and move back to the side. This gets more complicated when you have a videographer working with you who just stands in the middle of the floor.

During the candle lighting, you may find guests—and sometimes DJs or their dancers—jumping up next to you to take pictures. Employees of a company a family may hire to take "green screen" photos (e.g., mock magazine cover photos, which are given to guests as party favors)

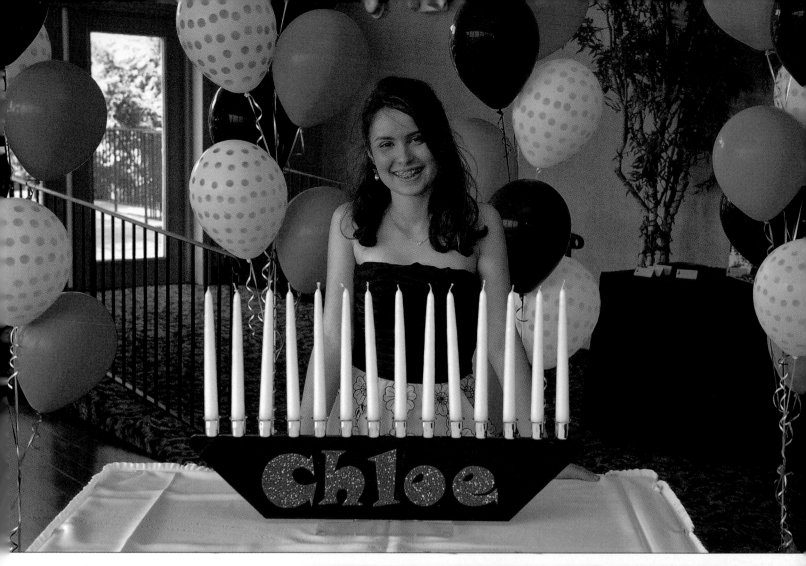

Above—Pay attention to the height of the candles used In the candle lighting. In this case, a test shoot was taken to be sure about where the candles would end up in relation to the bat mitzvah girl. Had they been any taller, we'd have needed to have the girl step off to the side for the images.
Right—Imagine what the image would have looked like had the photographer not used the balloons to enhance the background. Do you see the DJ? Make use of decorations to your advantage.

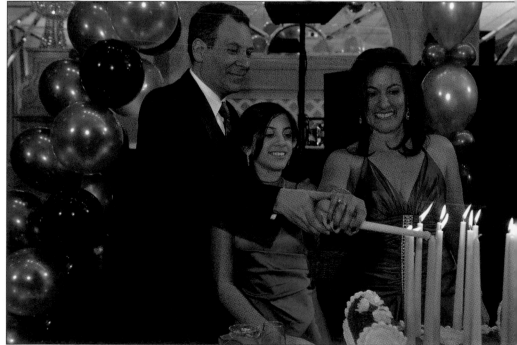

Top left and right—Try to get photos of the cake before they load it up with candles for a candle lighting ceremony. **Facing page**—Be sure to enlist the help of the DJ and hired dancers to get the kids into the group picture. Don't forget to include the siblings!

may also jump up next to you and start taking pictures. Since they are holding a camera, the attendees often assume they are working for me. When the guests see these people making a pain of themselves, it isn't good for business. I usually tell the family to ask them to stay put during the candle lighting.

CAKE PHOTOS

If the family has opted to have a cake at the ceremony, you will want to make a special effort to get a nice picture of it—before it is loaded up with candles, if it is being used in the candle-lighting ceremony. You may also want to get a photo of the mitzvah child with the cake.

Some cakes are elaborate, designer cakes made to suit the theme of the mitzvah. Others are homemade. Keep in mind that, like all of the other items that the family chose for the event, the cake should be documented.

KIDS' GROUP PICTURES

At some point during the festivities, you will want to get a photo of all of the kids at the party. This is where a good DJ can make your life so much easier. When I first show up at a party, I always discuss with the DJ when will be a good time for the group shot. Sometimes this is done after the candle lighting ceremony, or it may be after a game is finished.

Getting fifty or more kids together for a good picture takes the help of the DJ and any dancers they have working with them. I will typically

get three poses: a traditional group shot, one in which all of the kids are pointing to the mitzvah child, and one with all of the kids having fun—maybe making silly faces or cheering.

LAST DANCE AND GOOD-BYES

The last dance is just that—the last dance. There is no special song used to signify the end of the ceremony. Each DJ will have their own way of ending the party. Some may have the immediate family come to the center of the dance floor, surrounded by all of their friends and family. Others may just have the child walk around the circle and give everyone a hug. Be sure to communicate with the DJ to determine how they will wrap up the celebration. I know by this time, most photographers just want to pack up and go home, but take your time in doing so. Last-minute parting shots can be very important, and the family will think all the better of you.

COMMUNICATE WITH THE DJ TO DETERMINE HOW THEY WILL WRAP UP THE CELEBRATION.

I am always reminded how important the party is to my overall business and marketing when a guest comes up to me to ask for my card. Keep in mind that no one has seen any pictures yet, only the manner in which I work. It's all about attitude and the way you handle yourself throughout the day. I can have two mitzvahs on the same day, one in the afternoon and another that evening, and I will always keep a smile on my face while I capture the images.

It may not seem like it, but the guests and family are very much aware of your presence and your enthusiasm when working the event. In working mitzvahs, word-of-mouth referrals are everything. Remember that these are families that belong to the same synagogues, their kids go to the same schools, and many times they all go to the same mitzvahs.

6. AFTER THE RECEPTION

Photographing bar and bat mitzvahs typically ends after the reception. Occasionally, you may end up at a Sunday brunch for the out-of-town guests, but this is an add-on for us; it is not considered part of the mitzvah package. From here on out, it's all about production and maintaining a viable workflow for all of the postproduction tasks.

WORKFLOW

Over the years, I have seen many a studio start up only to fail due to poor customer service and postproduction problems. Finding an efficient and effective workflow solution is essential to a photographer's success, and, as such, it has been a major source of discussion among all photographers. Over the course of the last five years, we at Ahava Photography have made major changes to our systems. We first looked at the overall requirements of our business and then went into each segment of our day-to-day operations and fine-tuned each step of our processes for efficiency, cost reduction, and most importantly, the best-possible customer service.

The following is our current workflow process for all of the postproduction tasks associated with the mitzvah photography side of our

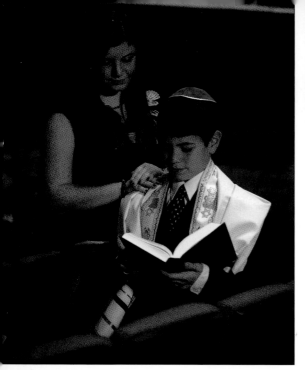

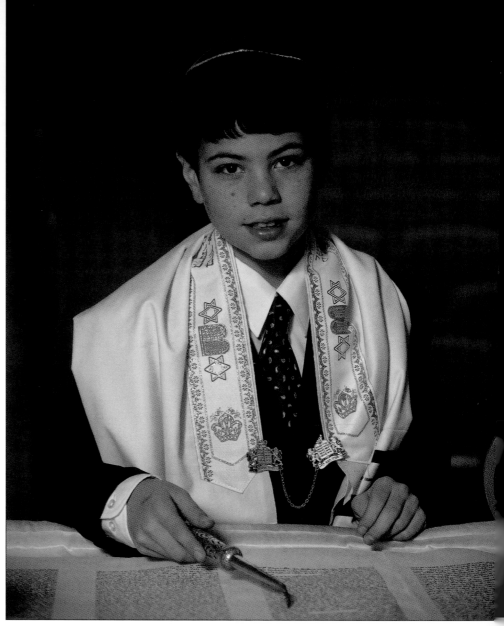

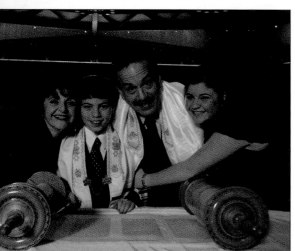

business. Keep in mind there are different processes for mitzvah and weddings, and each has its own customer service issues.

The Day After the Mitzvah Shoot. *Backups.* All images from the event (including the formal shots taken midweek) are backed up and stored on our in-house hard drives, burned to DVDs (which are placed in the client's file), and uploaded to a remote server, where they are stored and can be viewed by clients. No card is ever reused until all the backups are completed and we are sure that each file can be opened. Having multiple backup sources ensures the protection of the files.

I have heard horror stories about photographers losing their images while transferring files from their media cards onto their computers or hard drives while on location. CompactFlash cards have become so af-

Showing a small selection of edited images just days after the mitzvah will help keep the excitement over the event alive and will build enthusiasm about the ordering process.

fordable; I can't imagine why anyone would take the time and risk to back up their images on location. We have at least two dozen 8GB cards in use all year long. When a card is full, we simply insert a new one. No card is ever formatted after a job until all backups have been made and verified.

Once a year we give away all of our CompactFlash cards and buy new ones. Why not keep them? We have a high-volume studio and have found that problems (e.g., corrupt files) can occur in some of the heavily used cards. It is worth the cost of new cards to ensure peace of mind.

Editing. One selling point of our studio is the fact that our clients can see highlights from their event two days after the event. To achieve this goal, we must start the process of culling and selecting images for the highlights the day after the event. This is normally not too difficult to manage, but it can be a bit stressful when you have four events' images to prepare on the same day!

Choosing and using the right software can lighten your workload when it comes to preparing these images. We currently use Photo Mechanic and Aperture. Photo Mechanic allows us to cull, tag, and rename images quickly and efficiently. Aperture allows us to take these final selections and run color balance adjustments, crops, and any other changes required to fine-tune the images in a batch process mode.

Two days after the event, the client can view fifty to one hundred images from their event. Keep in mind these are only highlights; the remaining images will be worked on during the next couple of weeks and will be posted for the customer on a password-protected hosting site.

Two Weeks After the Mitzvah. Our goal is to have all of the customer's proof prints, album selection paperwork, and master image DVDs no later than two weeks after the event. We outsource our proof prints and proofs for press-printed books to a lab, which also hosts our images for customer viewing and online ordering. As mentioned earlier, this hosting site also keeps a backup of our images. We love this one-stop solution for our backup and printing processes.

Proofing. We have found that it is easier for our clients to review their proofs and make album selections on their own. We offer three options for proofing: an online hosting site (for online ordering), a master disc (which we provide), or traditional paper proofs. We have found that printed proof prints are still a requirement. Nothing beats putting

WE OUTSOURCE OUR PROOF PRINTS AND PROOFS FOR PRESS-PRINTED BOOKS TO A LAB.

the prints on the table and seeing what works well with what on a page layout.

MITZVAH PACKAGES

When putting together packages for mitzvahs, you will need to keep in mind that mitzvah budgets are different than wedding budgets. Here you have only one family paying for the entire event, and there may very well be two or three mitzvahs within one family (depending on the number of children)—all just two or three years apart.

We have tried several pricing plans, both with albums included and à la carte, where the albums are purchased separately. By far the best option is to have the family commit to an album from the start, and to

Photos that capture the beauty of the venue will be cherished by the family.

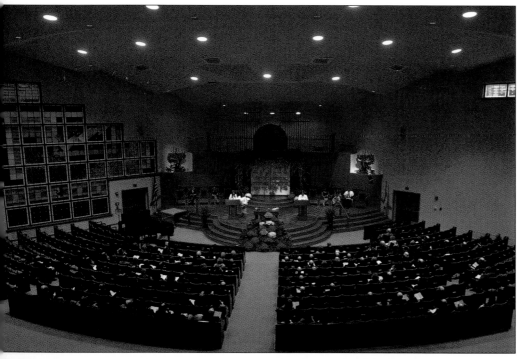

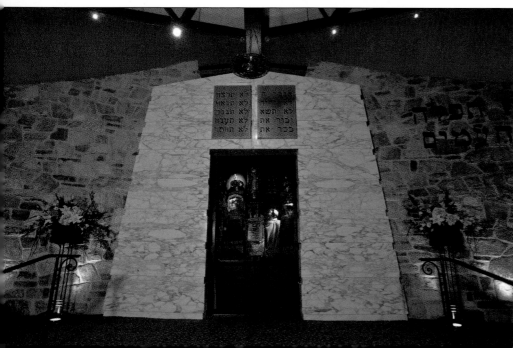

help, we provide a significant discount when the album is pre-purchased (included in the package).

With the recent changes to the economy, families are working with even tighter budgets, and our pricing has been adjusted to take this into account. We now offer press-printed books, which are available at a lower cost than traditional leather-bound albums, as well as smaller albums.

We do not focus on selling add-ons to families working with a limited budget, as doing so only distracts from the key objective, which is for them to have great photography and a well-crafted album that will stand the test of time.

ALBUMS

Albums for mitzvahs are very much the same as you would find in the wedding side of the business. We offer three styles of albums, all of which are 10x10 inches in size: traditional flush mount, collage style, and magazine style. Today, our most requested album is the magazine style.

ALBUMS FOR MITZVAHS ARE VERY MUCH THE SAME AS YOU WOULD FIND IN THE WEDDING SIDE OF THE BUSINESS.

- Traditional albums are flush mounted, with one image per side. Our basic album is twelve (double sided) pages, for a total of twenty-four images.
- Collage albums are ten (double sided) pages but include up to sixty images designed in a collage layout with a neutral background—white, black, or gray.
- Magazine-style albums are twelve (double sided) pages with about eighty images. The images are graphically designed in the magazine layout in spreads across two pages. They feature black & white images, spot coloring, half-tone images as backgrounds, and anything we think will enhance the look and storytelling aspect of the album.

Look at a few of the designs in this chapter, and you will see that the albums do a great job of telling the story of the mitzvah. Of course, there is a greater amount of postproduction work here, but many families are willing to make the extra investment for something truly special.

There is a growing trend these days to downsize the mitzvahs and have more of a religious ceremony with a small luncheon following the

service. There are also many families taking trips to Israel with the mitz-vah child.

All of this will have an effect on the type of packages you provide and the albums included in the packages. Press-printed books are also an option; we have had success with these and intend to grow our sales of these books in the future.

Here are a couple of sample page spreads from a mitzvah album.

7. FREQUENTLY ASKED QUESTIONS

The dos and don'ts for mitzvah photography can cause photographers new to the genre to wonder and worry—and that trepidation can result in missed photo opportunities and stifled creativity. So what's a photographer to do? The questions in this chapter should help you feel at ease and create your best work—in the most relaxed manner possible.

What do typical mitzvah photo packages sell for?

I thought this would be a good question to start with, as many photographers have very little point of reference for comparison. Just as in wedding photography, there are many considerations that determine the price of a mitzvah photo package, such as location, hours, style of photography, types of album designs, etc.

On average, a complete package that includes a finished album will sell in the range of $2000 to $4500. The higher-priced packages usually feature graphically designed albums. These are average prices, and there are definitely photographers selling packages well over the $5000 mark, based on talent and client base.

How much time is needed to photograph a mitzvah?

This is another great question. Mitzvah photography is broken down into two segments: The synagogue portrait session usually takes place midweek—on a Wednesday or Thursday afternoon—the week before the Saturday mitzvah service. The reception typically takes place Saturday afternoon or evening the day of the service.

The portraits at the synagogue mid-week take about two hours, and then the party on Saturday afternoon or evening will be around four hours. For a busy photographer, two mitzvahs on a Saturday back to back (afternoon and then evening) is common. When you compare this

If you are hired to photograph a combination bar and bat mitzvah for twins, factor joint and individual portraits into your photo time line.

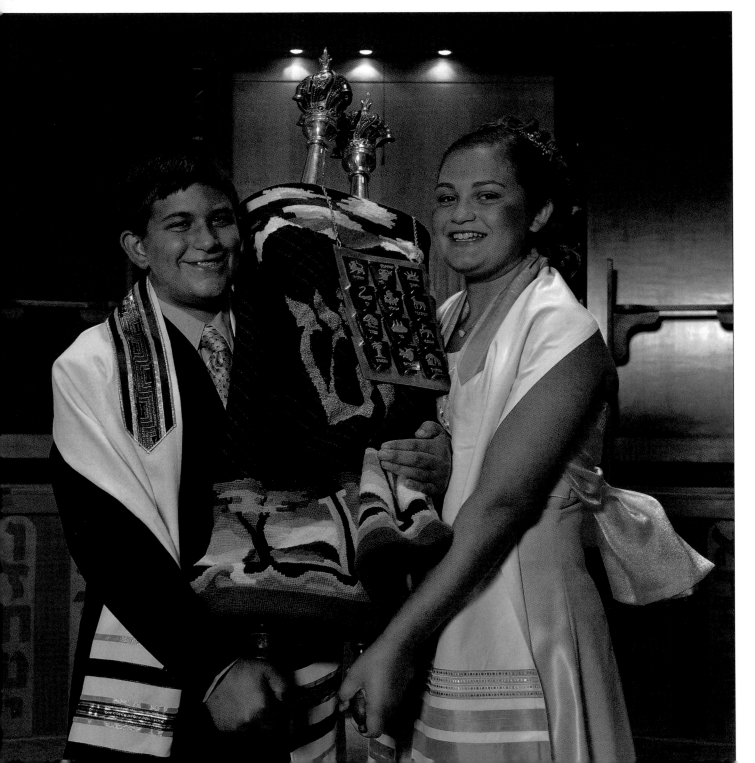

Bar and bat mitzvahs are big news—and big business. Your professionalism will help generate word-of-mouth referrals and build your business!

to most weddings, you can see why photographing mitzvahs can be very lucrative for some photographers.

How many mitzvahs are there each year in the United States?

This is a tough question. While there is much published data on the wedding industry, this is not the case for mitzvahs. In conducting research for this book, I was amazed at how little information is available about the size of the market. You have to keep in mind that Orthodox Jewish families are a very small percentage of the mitzvah market, as they generally do not have bat mitzvah ceremonies and the bar mitzvah is more of a religious event with a much smaller celebration. With this said, it should be noted that Modern Orthodox families have grown in number and should be included in the mix with Reform and Conservative Jewish families, which make up 95 percent of the mitzvah market. The best way to come up with a guesstimate is to look at the following breakdown of synagogues in the United States.

The total estimated number of synagogues in the United States is 3900, based on a census made by the American Jewish Committee. Of these synagogues, 40 percent are Orthodox, 26 percent are Reform, and 23 percent are Conservative.

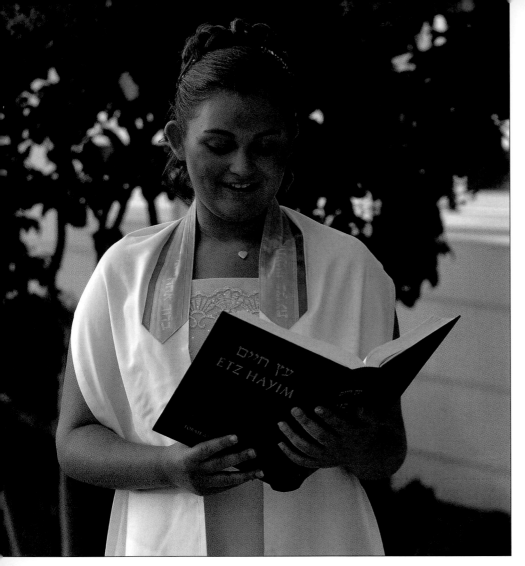

Lush foliage and pretty blossoms make a great backdrop for this bat mizvah's portrait.

Using an educated guess, it is expected that at least 55 percent of the total synagogues have families that will have mitzvahs in any given year. Now comes the hard part. Each synagogue has a different membership size, and the age of the members also factors in when estimating how many mitzvahs will take place in the synagogue.

Assuming that there are approximately 2100 synagogues with mitzvah families, and each will have about fifty mitzvahs a year (a big guess that is probably on the low side), then we end up with 105,000 mitzvahs a year. No wonder this has become a large industry, worth millions of dollars!

What are the seasons for mitzvahs?

Mitzvahs take place throughout the year, but there is a slow season during the summer months of July and August. The reason for this is that most kids are out of school and are away at summer camps. The party

following the mitzvah service is a big part of the scheduling and planning, so many families tend to wait until children are back from their summer vacations.

Keep in mind that winter weather and Jewish holidays also affect the planning of dates, so don't expect to see as many mitzvahs during the winter snow season and during Passover in the spring.

Are all mitzvahs held in synagogues?

There are many components to the religious aspect of the mitzvah, and reading from the Torah is a key item. There are many families that are not affiliated (members of a synagogue) but want to have their children participate in this rite of passage. They end up hiring a tutor to prepare the child way in advance, and they hold the service in a hotel or resort venue and have the child read or perform part of the service. This can be in the morning with a reception following or during the twilight hours with an evening reception.

Many rabbis disagree with this practice, but I have seen firsthand some beautiful and meaningful services with children who otherwise may not have had any religious orientation at this stage in their lives.

Is it okay to take photos during an actual service that is held on the Saturday of the mitzvah?

Generally, the answer is no. If the service is taking place in a synagogue, then the custom is not to have photography of any type. With that said,

Reading from the Torah is a key aspect of the mitzvah—no matter where it is held.

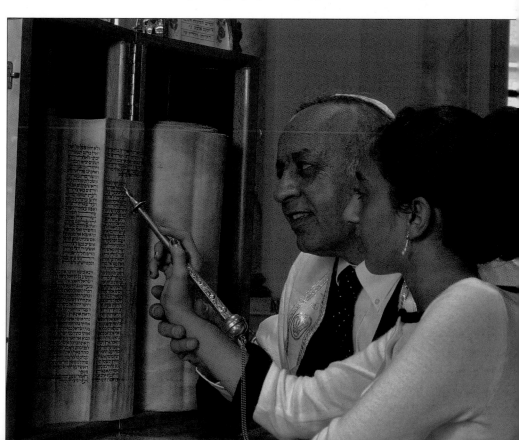

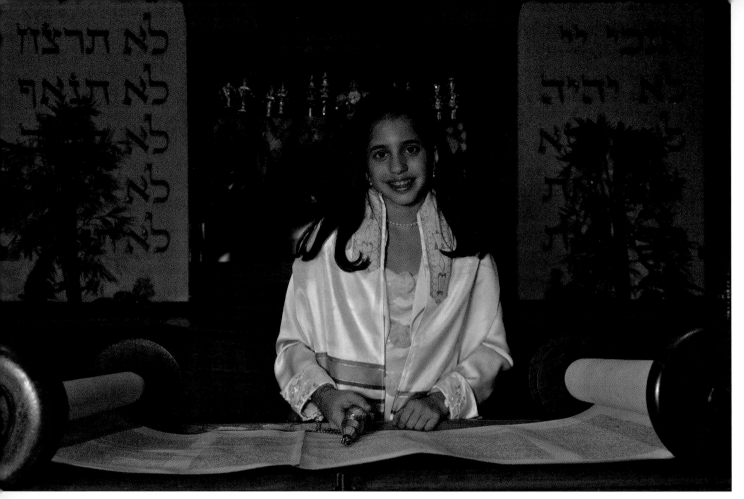

This bat mitzvah photo was taken at a Reform synagogue just an hour before the actual service. The girl was very relaxed and posed beautifully.

Reform synagogues are more relaxed about this sort of thing and allow photos and video, provided no flash is used and the photographer stands off to the side, so as not to cause a disturbance. This is why much of the formal photography is done at the synagogue midweek, when no religious service is being held.

Is it okay to use the Torah in photographs? I thought this was a very religious item and could not be touched or may only be touched by Jewish people. What is acceptable?

Reading from the Torah during the mitzvah ceremony is a key role taken on by the mitzvah child. It makes sense that the family would want pictures of the Torah and the child. Some of these will be images holding the Torah, while others will be actually reading from the Torah.

Here is where it gets tricky. The guidelines for what can be done with the Torah differ from synagogue to synagogue. Many synagogues will set aside a Torah that is not kosher (i.e., is damaged or has imperfections) and remove some of the parchment, producing a much lighter, "mock" Torah that is used only as a prop for photographs.

Other synagogues will allow you to photograph a "real" (kosher) Torah but mandate that it be handled only by a rabbi or cantor. There are also congregations that do not permit photographing the Torah, as they feel it is disrespectful.

As you can see, you will need to check with the congregation's executive director well before the date of the session to know what is allowed. Every congregation will have an executive director that oversees the operation of the congregation. He or she will have a support staff that works with vendors, congregants, etc. These are the people the photographer will be interfacing with.

Once you work with a given synagogue, keep a set of notes that outlines what was allowed in terms of photography. Note that all synagogues prohibit you from moving equipment or tables around. Photographers have been restricted from working in certain synagogues for this reason alone.

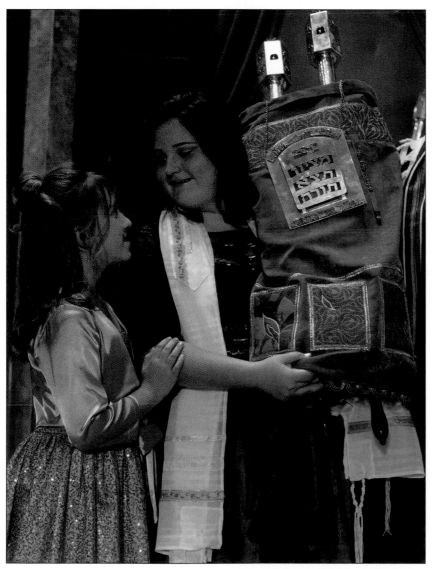

The bat mitzvah may differ from the bar mitzvah—depending on the denomination. Be sure you know what pictures will be expected before you arrive for the photo session.

Is there a difference in photographing a bar mitzvah boy versus a bat mitzvah girl?

There may be some differences depending on the affiliation of the family and the type of service the child has. For example, Modern Orthodox girls do not read from the Torah, so pictures of her reading from the Torah are obviously not expected; in the Conservative synagogue, however, the bat mitzvah girl does indeed read from the Torah, and photos representing this are expected. Be sure to ask the family whether their daughter will be reading from the Torah so you will know what to expect.

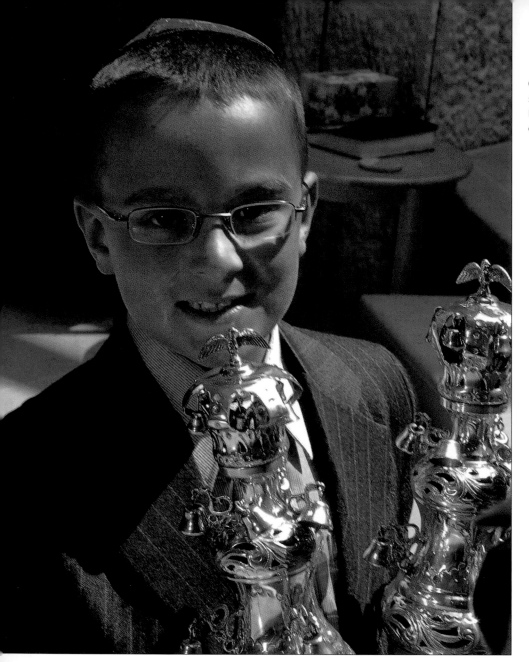

Getting siblings into photos can be as simple as having them bring items to you. Here, the boy was carrying the Torah covering.

How is a mitzvah different from a confirmation?

The confirmation originated with the Reform movement. Reform leaders felt that thirteen was too young of an age for children to be considered responsible, so the age of sixteen or even eighteen was used. This did not last long, as other children in the Conservative movement were having mitzvahs, and many children felt left out.

Confirmation classes are still held in many synagogues to keep children involved in Jewish studies after the mitzvah age and up through high school. When a child finishes these studies (between the age of sixteen and eighteen) a graduation ceremony may be held. There are no parties or special events associated with the ceremony, though.

Do I need to wear a kippah while working in the synagogue?

Out of respect, I always wear a kippah—even in a Reform synagogue where it is not always required. Being Jewish, this is how I was brought up, so while working in any synagogue, I wear a yarmulke (same as a kippah). Female photographers are not expected to wear them.

Does the rabbi have to be in the pictures taken at the synagogue?

This is a family preference, and on occasion, some families ask the rabbi to join in for a few photos. This is best handled by the family, and they can coordinate with the rabbi's office. Just be quick in working with the rabbi, since they normally only spend a few minutes with you. You may also find that the cantor will be asked to join in, as this is usually the person who tutored the child throughout the year in preparation for reading their portion of the Torah.

What is the best time of the day to take photos at the synagogue?

By far, daylight hours are best, as you have the opportunity to use natural light in your images. Also, many synagogues have stained glass windows which are backlit during the daylight hours and are of little use at night time. You will find that many families try to schedule evening hours so they can come after work, but try to discourage this so that you can make the best use of daylight.

Also, keep in mind how tired everyone will be after working an entire day, going home to change, getting the kids ready, then putting on a smile for the pictures.

Do I need any special photo equipment to shoot inside the synagogue?

In the past, it was difficult to get much of the natural lighting and visual splendor of the synagogue with slower ISOs; therefore, slow shutter speeds and strobe lights were needed for the most part. With today's high-ISO digital cameras and a gelled light on a small roll-about stand, I can match any ambient light with excellent results. Each photographer has individual preferences regarding equipment, and my suggestions reflect what I am the most comfortable working with.

A fast, wide-angle lens is a must-have for close images with lots of background included, which is part of the beauty of shooting in a syn-

A FAST, WIDE-ANGLE LENS IS A MUST-HAVE FOR CLOSE IMAGES WITH LOTS OF BACKGROUND INCLUDED.

agogue. Just as important is a 200mm or better fast zoom for portraits and separation from the background. Each lens serves a purpose, and having both a wide angle lens and a zoom as options is ideal; with these fast lenses, I can work with shutter speeds that allow for handholding the camera and still pick up much of the natural light available with just a kiss of fill-light for interest.

I like to use remote flashes in the ark for a very dramatic light effect, so here a radio slave is a must. IR transmissions from your camera to a remote flash don't work for these types of shots.

Be sure to know the schedule of events before the celebration begins. Here, the bat mitzvah girl is making a grand entrance. You want to be sure you do not miss this.

What's special about photographing the party/reception for a mitzvah? Isn't it like photographing a wedding reception?

From a photographic equipment point of view, this is correct. There are the same large venues, dim lights, DJs or bands, etc. On the other hand, there will be special rituals such as the *kiddush* and *motzi* that you will be sure to stay alert for. In this book, you can find all of the common rituals, customs, and special moments you will need to be sure to capture for the mitzvah family.

How many pictures will I need to capture?

On average, I shoot and deliver three hundred to five hundred images. In general, about one hundred to one hundred and fifty images are taken at the synagogue, and the rest of the images are captured at the party. If there is a candle-lighting ceremony, the photo count will be on the higher end of the estimate. You will find that the number of images you capture will also vary depending on the type of venue, whether it is an afternoon or evening event, etc.

What about table shots? Do I really have to do them?

Yes. Many of the family members at these events are seniors and may never leave the table they are at. Miss the table shots, and you miss the last picture of Aunt Miriam. With most parties averaging one hundred to one hundred and fifty guests, you're looking at ten to fifteen tables. Get the photos. You'll be glad you did.

CONCLUSION

Photographing bar and bat mitzvahs is completely different than photographing weddings. For some photographers, mitzvah photography can be more financially rewarding than the weddings they shoot and provide even greater personal satisfaction.

Learning and understanding the meaning of the mitzvah will help fine-tune your photographic skills to capture these special occasions in a truly meaningful and artistic way.

While this book covers much of the ins and outs of mitzvah photography in a very practical, hands-on manner, it is always best to get first-hand experience. Go visit some mitzvah services at a local congregation. Sit in for the couple of hours it takes and observe all that is taking place—observe the child, the parents, grandparents, and extended family. While observing, think about how you might be able to create images that reflect the meaning of the occasion the week prior to the actual mitzvah ceremony, which is when you will be given the opportunity to photograph the mitzvah family. Look at all of the scenery around you—the ark, the stained glass, the windows, the bimah and any religious articles being used. How would you make use of this in your session with the family?

Be sure to visit several congregations—some Reform and some Conservative. By doing your homework up front, you'll get a feel for each congregation's unique qualities and rituals. You'll find the more exposure you get to the services, the more at ease you'll feel in working in these surroundings.

I can assure you, you'll always be welcomed, and if you take the time to ask a question here and there, you'll get much valuable information.

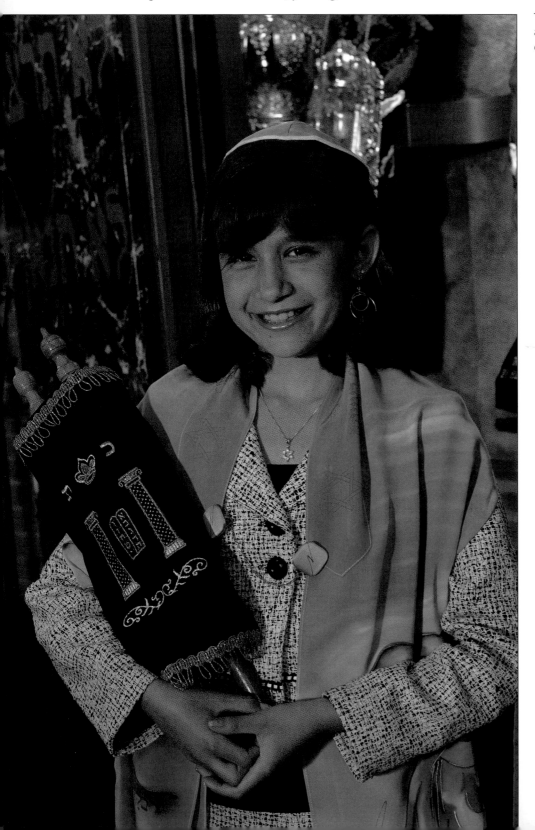

This beaming bat mitzvah girl is holding a mock Torah used by kids during children's services.

GLOSSARY

ARK. A wall opening or decorative cupboard in the front of the sanctuary where the Torah scrolls are kept.

BAR/BAT MITZVAH. A rite of passage moving a child into the responsibility of adulthood regarding the mitzvot, established for the boy at age thirteen and girls at age twelve (note, however, that most liberal synagogues do not make a distinction in age between boys and girls). The transition is automatic and is not dependent on ceremony. Ideally, the bar/bat mitzvah is an entry into formal Jewish education, since historically parents provided education in the early years. The ceremony for boys as we know it probably dates back to the Middle Ages, with girls' ceremonies not being practiced until the early 1900s in the United States. (Its performance is still limited in some liberal synagogues and is often nonexistent in Orthodox congregations.) In its early years, Reform Judaism generally discarded bar mitzvah in favor of confirmation, but it has been reintroduced over the last generations.

BIMAH. Literally, "high place." Refers to the raised platform (or pulpit) in the front of a synagogue sanctuary.

BRIT MILAH. The covenant of circumcision, which is usually performed on a male child in his eighth day of life.

CANTOR. In Hebrew, *chazzan*. The person who chants the liturgy during worship services.

CHUPPAH. A bridal canopy, used during the wedding ceremony and forming a sacred space in the center of the bimah. It may have its origin in the times when weddings were held outside and an effort was made to separate the wedding from the hustle and bustle of street life. It also symbolically represents the bridal chamber, where the couple would go after the wedding to consummate the marriage, fulfilling the obligations of Yichud.

CONFIRMATION. A ceremony that takes place during the Jewish holiday of Shavuot, originally introduced by the Reform movement to provide an alternative to the bar/bat mitzvah, now usually at the end of the tenth grade after bar/bat mitzvah. Early reformers believed children were too young to accept the responsibilities of adulthood and wanted an egalitarian ceremony for girls and boys. Confirmation was borrowed from Christianity.

CONSECRATION. A ceremony introduced by the Reform movement as the time when the child marks the beginning of his formal Jewish education, usually associated with the Jewish holidays of Sukkot or Simchat Torah.

DAVEN. To pray. The traditional Jewish posture of prayer.

DEVAR TORAH. Literally, "a word of Torah." A teaching of the sacred text either within or outside of the context of worship.

ETZ CHAYIM. Literally, "Tree of Life." A wooden frame used for holding and scrolling through the Torah.

FASTING. An act of abstaining from food or drink, mandated during several holiday observances, as a means of reflecting upon one's life. Not intended as punishment, it was historically connected to mourning customs, which, when engaged by an entire community, might "move the hand of G-d" by, for example, bringing on rain for farming.

HAFTARAH. Weekly reading on Shabbat and holidays from the Prophets, following the Torah reading. Its theme reflects the weekly Torah reading.

HAVDALAH. The ritual (using wine, candle, and spices) marking the end of Shabbat and holidays and the beginning of the rest of the week. It acknowledges the distinction between the holy and normative or the sacred and profane in time.

HORA. A circle dance traditionally performed at bar and bat mitzvahs and Jewish weddings.

JUDAICA. Religious items related to Jewish worship.

KIDDUSH. Sanctification prayer over wine for specific Jewish holidays and Shabbat.

KIPPAH. Plural, *kippot*. Hebrew for headcovering or skullcap, also called a yarmulke in Yiddish. The headpiece is worn in recognition that G-d is above you and for showing reverence to G-d.

KOSHER. Dietary laws that regulate the life of an individual Jew. "Glatt Kosher" is used today to refer to a generally higher or stricter standard of kosher.

The term is also used to refer to a "perfect" Torah that may be used in worship. In contrast, a non-Kosher Torah may have damaged letters or some other flaw that prevents its use in religious ceremony.

MAFTIR. The additional (eighth) Aliyah and reading of the Torah in which the last few lines are repeated, typically reserved for the bar/bat mitzvah who then recited the Haftarah. Variations may occur in liberal congregations.

MENORAH. Seven-branched candelabrum used in the ancient temple. The word is used to designate a lightbulb in Modern Hebrew and the synagogue Shabbat candelabra. It generally refers to the special menorah used for Hanukkah.

MINHAGIM. Customs.

MITZVAH. Plural, *mitzvot*. Refers to a specifically designated set of six hundred and thirteen commandments (positive and negative) traditionally acknowledged to have been given by G-d or decreed by the rabbis. Generally used to refer to a good deed (mitzvah).

MOTZI. A blessing over bread.

NER TAMID. A light fixture that is part of the ark structure. This is representative of the days of Moses when he instructed the Israelites to keep a flame eternally lit near the holy scriptures.

RABBI. Hebrew for "my master." A term used during the first century as a mode of address to authoritative teachers who were ordained members of the Jewish senate. Community religious

leaders whose office developed in order to teach and judge, a result of the introductions of the notion that oral law and the disintegration of the power of the priesthood with the destruction of the temple. Today, rabbis are generally more localized to synagogues.

SHABBAT. The Sabbath, also known as "Shabbos," observed from sunset Friday evening to sundown Saturday evening. The time is marked by rest, worship, and study. One who traditionally observes the legal requirements of Shabbat is called shomer Shabbat or shomer Shabbos.

SHALOM. Usually translated as "peace," "hello," and "goodbye," it really refers to wholeness and completeness. The world is not whole or complete without peace and tranquility; hence the transfer of terms. The sense of hello and goodbye developed as abbreviated forms of the greeting or inquiry, "Is your clan at peace?"

SIDDUR. Prayerbook. The Hebrew word for order, because it establishes the proper order for the recitation of prayers.

SIMCHA. A happy, joyful occasion, usually a family life-cycle event, such as a bar/bat mitzvah or a wedding.

SYNAGOGUE. Called "shul" in Yiddish and often referred to as "temple" in more liberal circles, this is the central house of worship for the Jewish community following the destruction of the ancient temple.

TALLIT. Prayer shawl. Reminiscent of the robe-like garment worn by our desert ancestors. Four fringes (tzitzit) are attached to remind us of our responsibilities to G-d. The shawl is worn at morning prayer and is also commonly used as the cloth in a chuppah (the wedding canopy).

TEFILLAH. Plural, *tefillot*. Prayers referring generally to worship.

TEFILLIN. Phylacteries, or prayer boxes, strapped to the head and arm, which are worn during daily morning prayers, but not on holidays or Shabbat. They are a sign of the covenant between G-d and the Jewish people.

TEMPLE. Refers to both the ancient sacrificial center and central edifice for divine worship in Jerusalem. The First Temple was destroyed in 586 B.C.E. and the Second Temple was destroyed in 70 C.E. Today, this is the site of the Dome of the Rock, a Moslem mosque. The term is interchangeably used with synagogue by Reform Jews because the early Reformers rejected a return to

Jerusalem if it meant a condemnation of the diaspora.

TZITZIT. The fringes on the tallit, which are used to touch the Torah before reading from it.

WIMPLE. A Torah binding used to hold the scrolls together. Made from swaddling clothes of an infant and worn at the brit milah, it is traditionally given to the synagogue in honor of a boy's first birthday. It is sewn together and embroidered with his name, birth date, and a prayer for him.

YAD. Literally, "arm" or "hand." A stick with a hand at the tip used as a pointer for the reading of the Torah so that one does not touch the scroll itself.

YICHUD. The symbolic consummation of one's marriage, just following the wedding ceremony, represented by the chuppah. Many communities allow for private time just after the ceremony in order to recognize it.

YIDDISH. High German with a mix of words borrowed from other languages, depending on where the Yiddish is spoken. A folk language associated with Eastern European Jews.

INDEX